Praise for

THE HEART: FRIDA KAHLO IN PARIS

"An intimate, unforgettable portrait of a brief but transformative time in Kahlo's life and of the turbulent beginnings of France's Surrealist Movement."
—*Foreword Reviews* (starred review)

"A breezy bit of art history about a 1939 affair between the author's father and Frida Kahlo in Paris...the story is transportive and dreamy." —*Kirkus Reviews*

"Incredibly lively and sensitive...a book that takes an important place in the bibliography of this modern Mexican heroine." —*Connaissance des Arts*

"Superb... [Petitjean] enables us to discover the artistic Paris of the interwar period."
—*La Presse de la Manche*

"[Petitjean] paints a portrait as personal as it is perceptive of the intrepid Mexican [artist], while reviving the colors of the ebullient interwar art scene. Captivating." —*Paris Match*

"Marc Petitjean grew up in Paris with a haunting picture by Frida Kahlo on the walls of his family's modest apartment. Decades later, a stranger asked him

about his father's love affair with Frida. This revelation, out of the blue, spurred him to investigate what had happened between them. The result is an intimate portrait, beautifully written, not only of the two lovers, but of bohemian Paris and its most influential figures, at a turning point in history: the eve of war, in 1939. *The Heart: Frida Kahlo in Paris* beats suspensefully with real life."

—Judith Thurman, author of *Secrets of the Flesh:*
A Life of Colette

"This book gives a poignant picture—part imagined and part true—of Frida Kahlo's days in Paris among other surrealists during a show of her paintings. It's told by the son of a French lover to whom she gave her powerful painting, *The Heart*, who was searching to understand his father better."

—Laurie Lisle, author of *Portrait of an Artist: A Biography*
of Georgia O'Keeffe and *Louise Nevelson: A Passionate Life*

THE HEART: FRIDA KAHLO IN PARIS

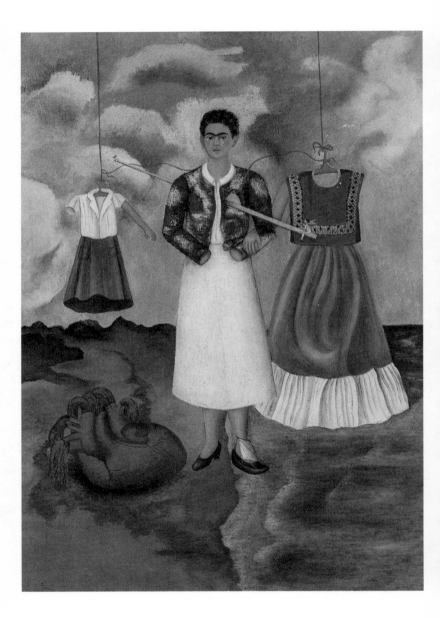

THE HEART

Frida Kahlo in Paris

Marc Petitjean

Translated from the French by Adriana Hunter

Other Press / New York

Library of Congress Cataloging-in-Publication Data

Names: Petitjean, Marc, author. | Hunter, Adriana, translator. | Petitjean, Marc. Coeur.
Title: The heart : Frida Kahlo in Paris / Marc Petitjean ; translated from the French by Adriana Hunter.
Other titles: Coeur. English
Description: New York : Other Press, [2020] | "Originally published in 2018 as Le Coeur: Frida Kahlo à Paris by Arléa, Paris." | Includes bibliographical references.
Identifiers: LCCN 2019035162 (print) | LCCN 2019035163 (ebook) | ISBN 9781590519905 (hardcover) | ISBN 9781590519912 (ebook)
Subjects: LCSH: Kahlo, Frida. | Kahlo, Frida--Friends and associates. | Painters—Mexico—Biography. | Expatriate painters—France—Paris—Biography.
Classification: LCC ND259.K33 P4813 2020 (print) | LCC ND259.K33 (ebook) | DDC 759.972 [B]—dc23
LC record available at https://lccn.loc.gov/2019035162
LC ebook record available at https://lccn.loc.gov/2019035163

TO

Freydelyne Charles

My wound existed before me,
I was born to embody it.

—JOË BOUSQUET

A MEETING

Oscar, a Mexican writer whose name I did not recognize, contacted me on the Internet to arrange a meeting. He said simply that it was about my father. I was intrigued because my father had been dead for more than twenty years. We met in Paris, on the corner of rue du Temple and rue Dupetit-Thouars. He took four typed pages from his leather briefcase and handed them to me.

"So," he said, "I wrote this article using the archives of the Mexican artist Frida Kahlo, and I discovered that your father had an affair with her when she came to Paris in 1939."

I knew my father had known Kahlo and that she had given him a painting called *The Heart*, but

he had never mentioned any sort of relationship with her.

Frida Kahlo is now seen as one of the most important artists of the twentieth century, and she has achieved icon status in Mexico; I was well aware of that. But what really happened between her and my father?

Oscar's piece provided a little information about how the lovers met and the three weeks they spent together, and referred to some letters written by my father after Kahlo left. My Spanish is not good so I did not understand everything, but I felt that the author had overplayed things, using scant material to speculate about the intensity of the relationship. Most likely, no one would ever know what they actually experienced, but I still felt their connection must have been fairly powerful or unusual to justify Frida Kahlo's gift of one of her paintings.

I saw Oscar again before he returned to Mexico. We met at the café Zimmer on the place du Châtelet, and I asked him why he was interested in my father. He explained that the idea of this affair appealed to him and he wanted to know more about the artist's time in Paris in 1939. He was convinced

that my father had received letters from her, and he hoped that I would pass them on to him. But I had found nothing apart from a telegram sent from the ocean liner *Normandie* when Kahlo sailed from Le Havre. It said, "Thinking of you so much Michel." Oscar's curiosity kindled my own, and I in turn embarked on researching the lovers' lives.

When he met the Mexican artist in 1939 my father was twenty-nine and she thirty-two. He was an ethnologist, agronomist, left-wing militant, and journalist who moved in artistic social circles. Twelve years elapsed between their meeting and my birth—five of them war years. I realized that by revisiting my father's past I might discover another person, very different from the man I had known; younger, of course, but with all the hopes, opinions, preoccupations, and commitments of his era, on the eve of the Second World War. The author Claude Mauriac described him in his memoir as a "cheerful bumpkin" with a funny, charming, baby face. The man I knew was certainly charming and elegant but also a little depressed and not especially amusing.

I thumbed my way through books devoted to the life and work of Frida Kahlo, looking for known facts about her time in Paris. The main biographies that I read attached little importance to this Parisian episode: thirteen pages, for example, in Hayden Herrera's book, which runs to more than five hundred pages and is the best-documented work to date. Several authors described Frida's trip to Paris by drawing almost exclusively on the three letters she sent to Nickolas Muray or to friends; letters in which she is very critical of the French, whom she found boring and pretentious—probably with good reason, but it would be nice to know more.

I remember the painting The Heart hanging on the wall in the living room when I was a child. It was small and eye-catching, framed in faded red velvet. The image disturbed me for a long time with its stark depiction of a huge, bleeding heart lying on the sand, and a woman with no hands whose body is pierced by a metal rod and whose eyes seemed to stare at me. I felt a sort of vertigo if I looked at it for too long: I was afraid I would topple right into that terrifying world. It was only later, when my adolescent self could identify the painting with the eccentricities of the surrealists, that I started to like it.

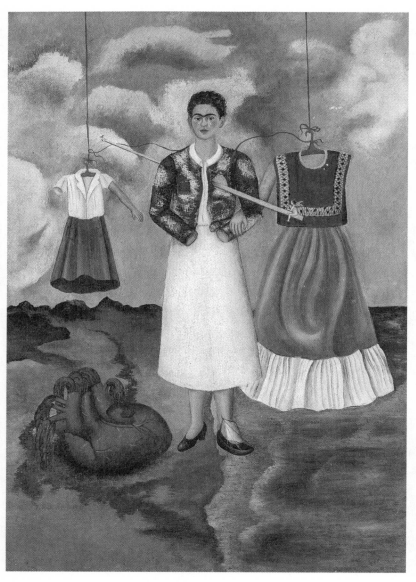

Frida Kahlo, The Heart, *1937, 40 x 28.3 cm,*
photographed by Olivier Petitjean

When I asked my father what the painting meant, he told me what the artist herself had said: the work has two names—*Memory* and *The Heart*—and represents Kahlo's transformation. At the age of seventeen she had a serious accident that caused a lifelong disability. On the left-hand side of the painting are the clothes she wore as a girl; in the center the European clothing she was wearing at the time of the accident; and on the right the traditional Native Mexican costumes that she then adopted, with a full, long skirt hiding her injured leg.

When he talked about her his tone of voice expressed respect and admiration, but I also detected something akin to reserve. Perhaps he preferred not to say too much in order to preserve the mystery surrounding their passion.

Did she specifically want to give him this painting or did he actively choose it among others? Either way, *The Heart* set a seal on their idyll.

On closer inspection, the painting feels more complex and dramatic than my father implied; the magenta velvet frame is reminiscent of Mexican votive offerings. The female figure at the center of the painting (a figure that represents Frida Kahlo) has a hole on the left side of her chest, where her

heart should be. A fine golden rod pierces diagonally through this gap. Tiny angels sit astride the two ends of the rod, using it as a seesaw. The face is serious, stares directly at the viewer, and has large tears rolling down its cheeks. The figure has no hands, and one of her feet, which is injured and stands on the sea, looks like a boat. She is positioned at the intersection of a symmetrically divided background: the upper half shows a blue sky filled with ominous clouds while the lower half is divided into two equal sides. To the left is a desert-like landscape with echoes of the background in the *Mona Lisa*. A huge heart lies in this landscape, with blood pouring from its severed arteries and flowing toward the sea on one side and toward the mountains in the distance on the other. The right-hand side of the lower half represents a desultory sea.

On the left-hand side of the painting and slightly set back, a red thread hangs from the upper edge of the frame and is tied to a coat hanger holding a girl's school uniform of white blouse and blue skirt. A bare arm—which is intriguingly the outfit's only arm—reaches toward the central figure. To the right of the portrait of Frida Kahlo, another outfit hangs in the same way: a red sleeveless top with gold patterning and a long green skirt

with a white flounce. The single arm emerging from this set of clothes is linked through Frida Kahlo's handless arm.

The image implies that some tragic event has taken place: blood flows, nothing is where it should be, and there is a general sense of instability. Frida Kahlo's face expresses both acceptance of the situation and remote awareness of the event. The rigorous composition reinforces the impression that everything is frozen and cannot move forward. The clothes are suspended like miners' overalls in a hanging room. The pain is so intense that the central figure is derealized and dismembered: her hands no longer belong to her, and her heart—a vital organ that is usually hidden and is the symbolic seat of emotions—is starkly exposed for all to see and disconnected from her body.

What did my father know about Frida Kahlo when he met her? Probably not much, like most people in Paris at the time. In 1930s Europe she was not known as an artist; she was Frida de Rivera, married to the internationally renowned muralist Diego Rivera. She was the "artist's wife."

———

When Frida and Diego married in 1929 she was eighteen and he twenty years older. Standing six feet one and weighing 330 pounds, with an intense face, bulging eyes, and an impassioned, unpredictable personality, the "ogre" was as attractive as he was frightening. Their relationship was tempestuous, passionate, extravagant, and painful, but Frida always put Diego first whatever the situation and she swore her admiration and unbounded love for him till the end of her days.

In 1933 she discovered that Diego was having an affair—and probably had been for the last two years—with her sister Cristina, to whom she was very close. This first infidelity of Diego's, which was followed by many others, profoundly affected her trust. Devastated by the pain, she left for New York, cut her hair, and replaced her traditional Mexican clothes, which Diego dearly loved, with fashionable first-world outfits. This was how she chose to mark her breakup and her independence.

In The Heart *she alludes to three periods* of her life: on the left-hand side of the painting hang the schoolgirl's white blouse and blue skirt that she wore when she met Diego. The central figure of Frida, with her short hair and modern clothes,

represents her as an adult at the time when she realizes that Diego is cheating on her with Cristina. On the right is the Tehuana costume that characterizes the wife emotionally attached to her Mexican identity. The ripped-out heart lying bleeding on the ground expresses her pain. The boat is a reference to the orthopedic shoe she had worn since contracting polio as a child; the metal rod represents a rail that impaled her during a trolley car accident. The painting can, however, also be read as a form of forgiveness, because the Frida of the Mexican costume—which Diego so liked—is arm in arm with the angry Europeanized Frida.

The Heart brings together elements of the major events in the artist's life: her childhood polio, her terrible accident, and Diego's chronic unfaithfulness.

In my hunt for traces of Frida Kahlo, I found a box in the cellar full of letters and papers gathered together after my father's death in 1993. I still hoped to find a letter from her, but in vain. The bulk of this paperwork was his correspondence with art historians regarding interviews he granted them, and with conservators from museums abroad to

whom he lent the painting. I arranged the letters by date to establish a chronology of the painting's history, and then wrote to everyone who had corresponded with him in the hopes of learning a little more about him.

The truth is, it now occurred to me that I knew very little about my father's life.

Is there a place somewhere where the memories of all the dead are kept together? We can remember our own experiences at our leisure, but not other people's. This hypothetical memorial reservoir would help me sketch a picture of my father in his earlier years. In the absence of such a resource, I am left to imagine things, drawing on facts, witness accounts, snatches of information and memories, giving me free rein to conjure a character who may be something like the man he truly was.

I picture my father as a young man, sitting in his shirtsleeves on the edge of a bed and looking at *The Heart* by the glow of a bedside light. Then he takes a pad of writing paper and writes one of the letters that Oscar will later find in the artist's archives in Mexico:

April 7, 1939. Paris is gloomy, the fine weather has tried a few times, with no success. The atmosphere here is terrible and everything reeks of war, even my optimism is starting to crumble . . . I haven't forgotten you, I still stop and gaze at your painting for long stretches of time. I don't understand how you were so kind to a poor "average" sort like me. I send you lots and lots of kisses, that's how much I love you. With my love, Michel.

FLASHBACK

Unlike my father's life, Frida Kahlo's is widely known, and her work provides considerable information about her personality and experiences. I wagered with myself that as I researched what she was doing in the months before they met, I would then have access to my father's world. The one would bring to light the other: as soon as I knew who Frida Kahlo really was, it would be easier for me to imagine what it was about her that attracted my father, and from there what sort of man he was.

In January 1939 Frida Kahlo leaves New York bound for France aboard the transatlantic liner SS *Paris*. It is a luxuriously equipped ship: its art nouveau interior features combinations of curves, magnificent staircases, and colored-glass windows. She spends her time alone in a cramped cabin, reading and writing, making few visits to the movie theater other than when a film by Chaplin or the Marx Brothers is being screened. She is working on a canvas commissioned in New York by her friend Clare Boothe Luce, a playwright, editor, and war correspondent. The painting is in homage to the actress Dorothy Hale, who died by suicide in October 1938 by throwing herself from the top of Hampshire House, a building on the edge of Central Park. Once the painting is finished, her friend intends to give it to Dorothy's mother. At the risk of shocking this recipient, Frida has decided to depict the actress in the act of her suicide, because she herself is haunted by suicidal impulses.

But how to portray relinquishing the body? How to express the interminable length of the fall? She opts to represent it in three stages, with the body on different scales.

———

In the ship's spacious dining room Frida usually takes a table alone, conspicuously, as if asserting her single status without actively attracting attention. Those near her cannot fail to notice her, if only for her traditional Mexican clothes, her braids coiled on top of her head, and her countless brightly colored rings. She drinks copiously, preferably cognac. Some passengers are bold enough to make overtures to her, while the more conservative, who deem her too eccentric to mix with, avert their eyes and mutter comments.

On January 20, 1939, the day before she arrives in Le Havre, she takes her usual walk on the upper deck wrapped in a green shawl and half-heartedly watches some people playing quoits. Her thoughts are still in New York, where she has just spent three wonderful months with her new lover, the photographer Nickolas Muray. Shortly before she sailed, they breakfasted together at the Barbizon Plaza Hotel before going to Nickolas's studio at 129 MacDougal Street, near Washington Square, for a photo shoot.

He drew the curtains over the glass roof, turned on the spotlights, and put Frida in the middle of this light, which he intended to be as soft as a caress. Together they chose a blue dress with a white pattern and a voluminous white-and-gray blouse. She

braided her hair with a swath of dark blue fabric. A necklace of shells or animal bones can be seen around her neck behind a magenta rebozo draped subtly and nonchalantly over her shoulders. She assumed her pose, leaning slightly against the wall, her head tilted, her hands on her forearms. She liked the way he looked at her, the way he studied the light on her golden skin. You really do look like a princess, he kept saying, and she was happy to believe him. With him she feels like a little girl again, as when her father photographed her, before tragedies came and turned her life upside down. Her father saw her as she was, with her tomboyish looks, her impatient curiosity, her need to attract attention in order to be loved, and what he gave her—ritualized in snapshots—was proof that she mattered to him. She relives this ritual with Nickolas, her tall handsome lover, two-time United States fencing champion and bronze medalist at the 1932 Olympic Games. He is a famous photographer, known particularly for his color portraits published in major American periodicals such as *Harper's Bazaar* and *Vanity Fair*. Frida was seduced by his elegance and touched by his sincerity and kindness. The rebozo photograph symbolizes the depth of their union. She looks at the lens, watching him watching her, and for the first time offers the celluloid a calm,

gentle Frida. Later, when Diego Rivera sees the photographs, he will say she is as resplendent as a Piero della Francesca painting.

The lunch bell has sounded on the liner's decks. She regrets having to make this trip to Paris. She would have preferred to stay with Nickolas. Will he still be in love with her on her return in two and a half months? And what of Diego, the love of her life? Just before leaving New York, on January 9, she wrote to tell him that she needed him desperately, and that leaving for Europe was a sacrifice. How will she live without her "favorite-frog-toad" if she moves in with Nickolas?

The Mexican writer Oscar surmises that the liner arrives in Le Havre ten hours late on January 21 and that Jacqueline Lamba, André Breton's wife, is waiting for Frida with Dora Maar, Pablo Picasso's partner. A Mexican diplomat whom they meet on the train invites them to share his compartment for the journey to Paris. It seems that during the train ride Dora and Frida strike up a friendship. They are both Spanish speakers and live with great artists.

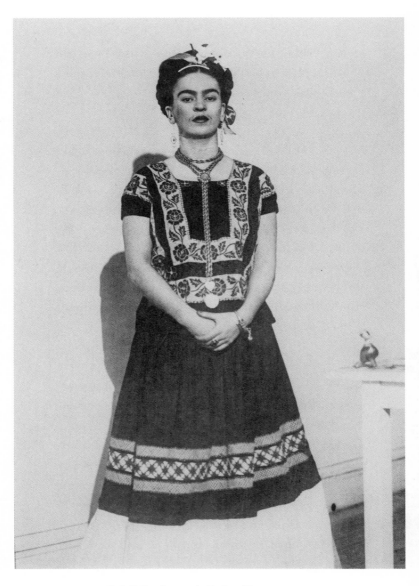

Frida Kahlo, photographed by Dora Maar, circa 1934.
Gelatin brome glass negative, 12 x 9 cm.

Martine Monteau, Jacqueline Lamba's biographer, suggests a different version, with Dora Maar driving Jacqueline to Le Havre to collect Frida.

At eleven in the evening Frida alights from the train at Saint-Lazare station and marvels at the sheer size of the building, but is still feeling a little seasick. She takes a few steps, then curses in Spanish as she tries to control her faltering walk, afraid her sea legs will aggravate the limp that she always hopes to disguise. Jacqueline and Dora chat behind her while they supervise the loading of a baggage cart with her two large trunks.

André Breton has come to meet them on the platform and waves his folded newspaper as he calls Frida's name. He is happy to see her and puts his arms around her. They pull back and smile at each other, watched by the other two women and the porter.

"You wanted me to come to Paris. Well, here I am, I'm here and I'm going to be so famous," she says, giving a twirl like a model parading a dress at a fashion show.

Other travelers stop in their tracks, intrigued by this young woman with olive skin and penetrating eyes, flowers in her braided hair and astonishingly colorful traditional Mexican clothes in

a place where everyone is dressed in gray, black, beige, and dark blue. A few admiring whistles bring a smile to Frida's lips.

The taxi they take stops at the Bretons' house at 42 rue Fontaine. André opens the green metal gate that leads into a long courtyard. At the far end is a building full of artists' studios that backs onto the boulevard de Clichy. The Bretons' apartment on the third floor has two rooms on split levels, linked by a small staircase. Frida is amused by the hundreds of accumulated curios here: bargain finds from flea markets, Oceanian shields, African masks, and paintings by Yves Tanguy, Joan Miró, and Marcel Duchamp.

In his book *Reading Writing*, Julien Gracq describes the apartment like this: "The profusion of art objects crammed against the walls gradually limited the available space; you could only walk around using specific paths established by habit, while avoiding the branches, vines, and thorns of a forest footpath along the way."[1]

There is nowhere in this hotchpotch to put Frida's luggage. At first she assumes this is André Breton's

studio and that their living space is nearby, perhaps on the floor above or across the landing. Jacqueline cuts short her conjecturing by taking Frida to the other side of the room and showing her their four-year-old daughter's small bed.

"You can sleep here," she says, "and we'll fix up a bed for Aube next to you."

"What the hell is this shit!" Frida asks, laughing out loud.

She was not expecting to be accommodated with so little consideration, especially after her recent time in New York, where she was queen of the art scene.

Frida is all the more surprised because the previous year she and Diego entertained the Bretons as distinguished guests in their home in the leafy residential neighborhood of San Angel in the south of Mexico City. Their home comprises two separate buildings designed by the architect and muralist Juan O'Gorman; both are very modern, with large bay windows and surrounded by luxuriant gardens enclosed by a cactus hedge, with a warm smell of eucalyptus hanging in the air. Frida and Diego gave the Bretons a huge bedroom and provided them with the attentions of house staff.

Jacqueline still talked about the Native Mexican woman who cooked meals in the garden.

In comparison, the Bretons' reception is disastrous, and Frida is incensed.

A few weeks after arriving in Paris she will write to Nickolas Muray to tell him of further grievances: "Until I came the paintings were still in the custom house, because the s. of a b. of Breton didn't take the trouble to get them out . . ."[2]

The truth is André Breton does not have a space in which to exhibit her work. He was planning to use the Gradiva gallery on rue de Seine, a site he used to run before his trip to Mexico, but this proves impossible. He tells Frida they will find another gallery, but his tone of voice implies he has more important things to worry about, which infuriates Frida. Her anger is only aggravated when she learns that her paintings are being held in customs and he has not had the time to deal with this.

The lack of preparation for her exhibition and the Bretons' casual attitude invite considerable speculation. In what circumstances did Frida and Breton meet in Mexico and why did Breton suggest that Frida have this exhibition in Paris six months later?

THE BRETONS IN MEXICO

The poet and essayist André Breton, recognized worldwide as the founder of the surrealist movement and called the "pope of surrealism" by his detractors, was committed to the French artistic and political scenes and generated an impressive output of books, exhibitions, and conferences. But all this activity, feverish though it was, never guaranteed him an adequate regular income, which was why, like his friend Paul Éluard, he also bought and sold primitive art. After his marriage to Jacqueline Lamba, a new muse fifteen years his junior, and the birth of their daughter Aube, he wanted some financial stability. Among other initiatives, he approached the French Ministry of

Foreign Affairs in 1936 in the hope of securing an assignment as a university reader. In 1938 the ministry finally offered him a program of conferences in Mexico on the subject of "French Art from the Eighteenth Century to the Present Day." He accepted the offer because Mexico was where Leon Trotsky, whom he admired, had found refuge. He hoped to meet Trotsky and cowrite a paper with him on art and revolution. Trotsky, a one-time ally of Lenin's and founder of the Red Army, was threatened with death by Stalin; he was taken in, along with his wife Natalia Sedova, by Diego Rivera, who was himself committed to President Lázaro Cárdenas's Mexican revolution.

On April 18, 1938, the Bretons disembarked in Veracruz, enthusiastic about discovering Mexico and escaping the stagnating atmosphere of Paris and the threat of war that loomed over Europe. They were swiftly disillusioned, because the embassy had made no arrangements for them. They were making plans to catch the next boat home when Diego introduced himself to them and invited them to stay at his home, in the company of Leon Trotsky, for the duration of their visit (a period of three or four months).

Frida Kahlo was waiting for them on the doorstep of the house in San Angel, shielding her face with her forearm until the dust raised by the car tires settled. Her eyes alighted on André Breton, who was first to walk toward her, dabbing his forehead with a handkerchief. She thought him handsome in his dark suit and tie with his lion's mane and solemn bearing. He smiled and bowed to kiss her hand, and she laughed at this rather outdated courtesy.

More than her traditional Mexican clothes, what instantly moved him were the dignity and strength emanating from Frida. But she had already turned her attention to the striking Jacqueline, with her glorious smile, milk-white skin, blond hair reflecting the light, and figure-hugging clothes. The two women kissed spontaneously and affectionately, like old friends. After they had passed through the cactus hedge, Jacqueline and André were dazzled by the sight of the house: the two very modern buildings reared up from the exuberant gardens, cube shapes with huge windows. Diego showed them the property: "The larger pink-colored Casa Grande is for the man, the master, and the smaller blue-colored Casa Chica is for the woman, for Frida." "Goddamn macho!" she cried, kicking him, and Diego jokingly informed them, "We use the walkway up

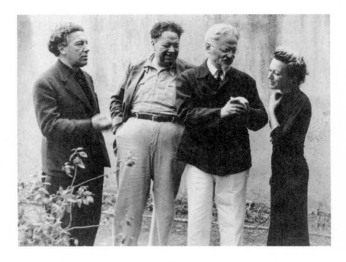

André Breton, Diego Rivera, Leon Trotsky, and Jacqueline Lamba, 1938.

there to visit each other." Jacqueline thought this the perfect setup, both had their independence with their own space and they could see each other when they wanted to.

The Bretons could not believe their eyes: the garden was like Noah's ark, with animals roaming freely and mingling with the artists and their visitors. There was an anteater, a spider monkey, a Mexican hairless dog, a fawn, and cats. Fountains, Aztec sculptures, and lush plants completed the

exotic setting, which reminded Breton of the idealized world depicted by Henri Rousseau, whom he greatly admired.

To his mind, Frida was the very ideal of a surrealist woman. She wore fantastical clothes, had a theatrical way of holding herself, wittily showing herself to her best advantage and expressing her opinions in refined, provocative terms, punctuated with curses. She was dark-haired and of average height, with olive skin, thick eyebrows, and flashing black eyes, and depending on her mood, she chose from an array of bracelets, rings, and necklaces made of precious stones, pre-Columbian settings, gold, and solid silver. He was fascinated by her smile and her temptress eyes, which subtly gauged the effect she was having on him. She seemed to be the one leading this game of seduction. But with Diego there—because everyone dreaded his furious outbursts—Breton did not risk responding to Frida's banter any more than decorum allowed. Besides, even while she was seducing a visitor, Frida could go and drape herself against Diego and tell him she loved him, which made approaching her a very delicate operation. She might be available, but fundamentally she belonged to Diego.

Breton's fascination with Frida was magnified when he saw her paintings in the studio. The first

piece he saw was *What the Water Gave Me*, a work in progress on an easel. On a stool beside it was a palette of fresh paints arranged in a circle, along with brushes soaking in glasses. Breton felt he was witnessing the unveiling of Frida Kahlo's most intimate depths, as if he were suddenly an accidental voyeur, discovering the process by which fragments of Frida's personality were crystalized on canvas in a vision. This feeling was coupled with his acknowledgment of a self-evident fact: Frida was a painter whose very essence was surrealist.

Using a similar technique to *The Garden of Earthly Delights* by Hieronymus Bosch, whom the surrealists much admired, Frida's painting depicts a bathtub half filled with dark semi-reflective water in which a dozen or so disturbing and dramatic individual scenes coexist, each symbolizing a painful physical or psychic episode in her life. The displaced people and things are portrayed in a variety of scales and therefore do not correspond with any concomitant reality. Breton could see connections to Salvador Dalí's work. At dinner that evening, after considering at length everything he had seen, which by then included several other paintings, he solemnly announced to Frida that she was a surrealist artist. She brushed this off breezily, uneasy about being labeled when she was not yet

sure she was even a fully fledged artist. He told her that the way she represented her dreams was wonderful, to which she replied that she did not paint her dreams but her own reality. He was not listening. As the "pope of surrealism" he could decide, and he explained rather patronizingly, as he might have done to a child, that she could easily be a surrealist without knowing it herself. On the strength of this, he then offered to set up an exhibition of her work in his Paris gallery after her show at the Julien Levy Gallery in New York in November. He labored his point by telling Frida that her future as a surrealist was already sealed, given that she had been approached by the Julien Levy Gallery, which specifically exhibited surrealists such as Salvador Dalí, Man Ray, and Max Ernst. To endorse his conviction and establish the young Frida in his surrealist circles, he offered to write the text for her exhibition catalogue. Breton had discovered an artist.

San Angel, June 15, 1938. The rain had stopped and the sun was back, warming plants, walls, and the ground, all of which exuded a fine mist and a

complex smell of earth, decomposing vegetation, and orchids. With the French windows open to the garden, Jacqueline and Frida were playing consequences, a favorite game with the surrealists in which each player adds a sentence or image to a piece of paper without knowing what the previous contributions were. When they reached the bottom of the page they unfolded it excitedly, each wanting to see what her friend had done and what she was thinking. Death and sex were the themes that recurred with greatest frequency, provoking uproarious laughter. *The crust is salty, bones are sweet, your prick goes in deeper, folding the embroidered linen.* They had taken to each other and spent a good deal of time together. Jacqueline was also a painter, and she and Frida discussed their thoughts on the work of Grünewald, Klee, Picasso, Piero della Francesca, and Giotto. Frida had chosen a popular pictorial style inspired by her country's ex-votos, partly to avoid elitism but also out of modesty, while Jacqueline was influenced by Matisse and Picasso. They sometimes conducted their long conversations naked on a bed and set out to discover each other's charming bodies. During these interludes Frida played the temperamental little girl constantly asking for proof that she was loved, requests that encouraged Jacqueline to be very creative.

Martine Monteau, who agreed to see me when she was working on a thesis devoted to Jacqueline Lamba, gave me a great deal of information. She told me that the Riveras went out in the evenings with their guests, attending village dances, boxing matches, circuses, movies, street theater performances, or El Salón México, a huge colorful dance hall that played Mexican music. Disabled by her leg, Frida would sit smoking and drinking tequila, cognac, or beer while she watched her friends dance. Like many Mexican artists, she rejected conventional behavior, spicing up her vocabulary with crude expressions all her own that involved unexpected juxtapositions of words, and delighted her entourage.

In 1937 Frida Kahlo and Leon Trotsky had had a dalliance that briefly evolved into a romantic affair. Even after ending the relationship, Frida continued to play the role of seductress with him. She called him the *viejito*,[3] and he treated her with a demonstrative gallantry that created tension in both of their official relationships.

André Breton, with his theory of *hasard objectif*,[4] adored everything about Mexico, its colors, its mixture

of Spanish and Native Mexican culture, the contrasts in its landscapes, its "Holy Death" cult, its combination of the pagan and the religious, its pre-Columbian sculptures, its workaday objects, its revolution, and the figure of Zapata. It was only natural that when Breton was happy, he should mention surrealism: "I think Mexico is surrealist in its topography, its flora, the dynamism afforded by its different races, and also in its highest aspirations."[5]

The Bretons' time in Mexico had overtones of social tourism. The Bretons and Trotskys roamed far and wide around the country with Frida, traveling in big black cars and accompanied by bodyguards. They visited Morelia, Lake Pátzcuaro, and Guadalajara. Diego joined them at various points. They would head home to Mexico City with the trunks of the cars filled with the Bretons' purchases: paintings, green ceramics from Patamban, painted earthenware masks, whistles, amulets, baskets, pre-Columbian statuettes, and jade necklaces. Trotsky, Breton, and sometimes Diego spent hours discussing communism, art, philosophy, and esthetics. Frida lost all interest in art and politics as soon as they were explored from a theoretical point of view. In fact, she thought the poet pretentious and too intellectual: "The trouble

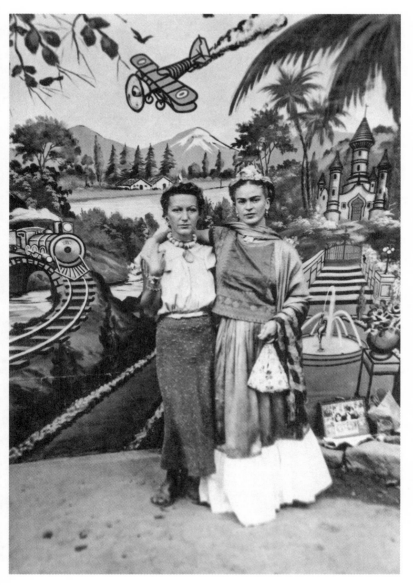

Jacqueline Lamba and Frida Kahlo, 1938.

with el señor Breton is that he takes himself so se-
riously!"[6] While the men talked, Jacqueline and
Frida, who were excluded from these discussions,
stayed away and enjoyed surrealist occupations,
drawing, board games, and children's games.

Together with the countless objects they had collected,
Jacqueline and André embarked on the *Iberia* in
Veracruz on August 1, 1938, bringing an end to
their Mexican trip.

FRIDA AND THE SURREALISTS

I looked out of the window at the Doucet Library and watched pigeons fluttering around the Panthéon while I waited for the librarian to bring me the documents I had requested. In a file I came across a letter to my father from Charles Ratton, a great collector and dealer in primitive art with whom he worked, mostly to set up exhibitions of African and surrealist art in his gallery. The letter is dated August 22, 1938, three days after the Bretons returned to France:

> *We went to Boulogne with Aube and Tanguy to wait*
> *for the* Iberia, *which was bringing the Bretons home.*
> *They're enthused by their trip and by Trotsky and have*

brought back many cases full of everyday works of art
that we watched them unpack. André is planning to have
an exhibition of them. I don't really share his admiration
for them and if he asks me to have the exhibition in rue
de Marignan I'm not sure what I'll say. Some more or
less primitive-style nineteenth-century paintings. Not
many archaeological pieces, and all of them of very
average quality.

Breton does not appear to have mentioned Frida Kahlo's paintings when discussing his plans for an exhibition with Charles Ratton.

From the early 1920s Charles Ratton collected, bought, sold, and loaned (to individuals and museums) works of art from Oceania and Africa, oriental and pre-Columbian archaeological finds, and Far Eastern ceramics and bronzes. My father had told me about him:

He started as a dealer at Le Bon Marché, he loved
"things," he could see what was good and what wasn't,
and was highly respected. His gallery was at 14 rue
de Marignan, a ground-floor space that led out to a
small garden. There were many pieces in his collection—
particularly the African art—that I knew from my time
at the Museum of Ethnography. I then quickly learned
about the pre-Columbian artifacts and some from other

sources. There were just the two of us at the gallery, I
was responsible for inventorying and photographing the
pieces, greeting clients, and putting on exhibitions.

They organized a weekly dinner at the gallery
with the surrealists André Breton, Paul Éluard,
Georges Hugnet, and Man Ray. It was during one
of these dinners a few months after Breton had
returned to France that he asked Ratton to house
his planned Mexican exhibition in his gallery.
The dealer must have expressed his reservations
as to the artistic merit of some of the pieces and
declined the suggestion. On the other hand, he
offered to loan a few good pieces from his collec-
tion to "raise the standard" of the exhibition. My
father would arrange the loan of these works. All
that remained was to find a gallery in which to
house them.

At the time my father lived with his mistress, Marie-
Laure de Noailles, in her private mansion on
the place des États-Unis. Marie-Laure—a writer,
painter, and sole inheritor of a vast fortune—
subsidized the surrealists as well as musicians such
as Igor Stravinsky and Georges Auric. She was
emphatically modern and not afraid of shocking

her social circle with her eccentricities. She had a cubist villa built in Hyères and financed Buñuel's film *L'Age d'Or*, which caused outrage when it was released. She threw huge parties where members of the aristocracy mingled with avant-garde artists. Claude Mauriac described what would have been an everyday scene at her home:

> Michel Petitjean drove me to Marie-Laure de Noailles's house on the place des États-Unis . . . We went into the garden that had windows on every side and where a milky light filtered from the absinthe-tinged chestnut trees. We played "portraits": Which scene from the Bible would he or she be? Which ocean? etc.—a game in which all the players deploy tremendous subtlety, which they are often alone in appreciating. At about midnight Gaston Bergery [a left-wing politician] arrived. He joined the game and played it with meticulous intelligence. Bettina has a cool, acerbic beauty. If she were a fruit? She would be a grapefruit. If she were a spirit? She would be a gin.[7]

On February 16 Frida Kahlo wrote to Nickolas Muray from Paris to say that Marcel Duchamp had immediately resolved the question of a gallery, and she spoke of him as a wonderful painter, not like these surrealist "son[s] of bitches."[8] Was Frida

trying to establish him as some sort of hero, in comparison with Breton, whom she could no longer abide? Did Duchamp reach out to the Renou et Colle gallery himself? It is more likely that the connection succeeded thanks to Breton's direct contact with Charles Ratton. Pierre Colle had already exhibited several surrealists—Dalí, Picasso, Miró, and Man Ray—and his relationship with Breton was both professional and social. Breton would introduce him to his future wife Carmen Corcuera y Mier, a member of Mexico's high society and a muse of Christian Dior.

My father knew Carmen well and told me she had confided that Pierre Colle had decided to put on the *Mexico* exhibition as an homage to her.

Another aspect of the tensions between Frida and Breton appears in a letter to Nickolas Muray. Frida complains that Breton wants to exhibit her paintings alongside Mexican nineteenth-century portraits, thirty-two Álvarez Bravo photographs, and a large number of everyday items. The icing on the cake is that he is borrowing two hundred dollars from her to restore the old portraits, and this work is likely to compromise the planned dates for the exhibition.

Understandably, she expected and hoped to be exhibited as a solo artist, as she was at the Julien

Levy gallery in New York, and interprets what she sees as backtracking on Breton's part as a repudiation of her work. Relegated to second place behind Breton's more general project based on his surrealist vision of Mexico, she feels betrayed and abandoned, and a very long way from Diego and from Nickolas, who gratified her by seeing her as a great artist. This feeling that she has been discredited evolves into a rejection of Breton and his surrealist friends, who are still just as deferential to their master, and redounds on her perception of Paris and the way she describes it in her letters. She considers canceling her involvement in the show but remembers how important Diego said it was for her to have an exhibition in Paris. Besides, she does not want to have made the trip in vain. She could have refused to advance Breton the money to restore the older paintings, but having eventually, and reluctantly, accepted the plan for her works to share the picture rails with others, she might as well do everything in her power to ensure the exhibition goes ahead as soon as possible. It seems likely that Frida Kahlo is prey to a sustained feeling of frustration and that this overrides the positive aspects of her time in Paris.

Breton meanwhile may not have told Frida what he intends to do: the *Mexico* exhibition has become

an artistic project in itself, something personal and intimate, a combination of components that he deems surrealist and that bring his concept to the fore. Frida's paintings form one of these components, probably the key element in the overall package. And yet she is given no opportunity to comment on the choice of works or how they are to be displayed. Breton hopes that by exhibiting these different artistic statements in Paris, he will allow others to experience the responses he felt in Mexico, a place whose geographical nature, history, and collective imagination he feels are supremely surrealist. All his feelings were embodied in the art and objects on display: his perception of Mexico and its history, recollections of excursions and of sourcing objects, strolls through markets with Diego, and conversations with the collector Chucho Reyes Ferreira, an artist and dealer in primitive altarpieces.

The *Mexico* project is the sum of all these parts concretized in the form of an exhibition. His article "Souvenir du Mexique" (Memories of Mexico), which appeared in the review *Minotaure* in May 1939, reveals the exotic, fantastical, and erotic perception he had of the country and its population: "Red soil, virgin soil impregnated with the most generous blood, a land where human life is

priceless, always ready, just like the agave plants that spread as far as the eye can see and that express this life, to be consumed in a flower of desire and danger." What he saw and experienced in Mexico resonated with what he had previously seen and read about the country, particularly in the adventure book *Costal l'Indien*: "The indelible impression I have retained from one of the first books I read when I was still a child and that Rimbaud mentions discovering at the same age." In *Costal l'Indien*, published in 1852, the author Gabriel Ferry describes scenes from the Mexican war of independence. He wants to introduce other people to this country, which he himself finds strange, quaint, repulsive in its social inequalities, and dangerous for its levels of violence. The storylines he develops, often coupled with humor, are by turns burlesque and terrifying. He has a visual writing style, even the most trifling descriptions are colorful and precise, the reader feels as if he or she is right there: "The Indian's half-naked limbs still steamed like a racehorse. Without troubling to disperse the whirls of fine mist that the cool night air was condensing around him, the Zapotec set off again with that athletic stride so peculiar to all Indian peoples, and I soon saw him climbing down the opposite path on the far side of the plateau. A few minutes

later, through the silence of an already paling night, I heard the hoarse reverberating notes of the Indian traveler's conch shell."[9]

In Minotaure *Breton writes* one sentence that displays uncharacteristic simplicity and modesty, and that could have brought about a reconciliation with Frida: "Who knows whether the greatest literary ambition should in fact be to write adventure stories for children?"

Oscar contacted me again a few months after our first meeting. Angela, a Mexican art historian friend of his, was coming to Paris and also wanted to meet me.

We met at the café Zimmer. Angela talked passionately about Frida, whom she sees as a chameleon, adapting to everything and everyone, and drawing the inspiration for her paintings from everything she sees, hears, and reads...But there was one thing Angela could not let go: Frida liked to keep in contact with the people she loved or had loved. She wrote extensively, and Angela found it

surprising that she had not written to my father, because, even though the affair appears to have been short-lived, it was intense—otherwise she would not have given him the painting...

I told her what I had told Oscar: I found no letters from Frida among my father's papers. But perhaps he destroyed them, although this strikes me as unlikely, or lost them in a house move.

The ensuing silence gave us an opportunity to envisage another possibility: the relationship may not have meant anything to Frida after all. Noticing my disappointment, Angela acknowledged that Frida might not necessarily have talked about every aspect of her private life. She may in some instances have been discreet and kept secret some feeling or event that touched her deeply. She was such a complicated person, Angela said.

Since returning from Mexico, André Breton has been remembering meeting Jacqueline five years earlier, and considering his fascination for her over the years and the love in which he is gradually losing interest. He gauges the depths of the

abyss threatening to swallow him: without a love that transcends him, he is nothing.

In the apartment on rue Fontaine Frida and Jacqueline have quickly resumed the affinity they enjoyed in Mexico. Frida has unpacked clothes and jewelry that she brought as gifts. Jacqueline chooses a top and then a full-length traditional Mexican dress. Frida removes her blouse and puts necklaces made of stone, ceramic, and metal around her neck. The reciprocal compliments—you look so elegant, so beautiful—are coupled with fondling of one another's breasts, arms, and faces. Then come long, sensitive, and exquisitely sensuous kisses. It is said that André Breton delighted in watching them.

The Bretons' day-to-day life is normally well regulated and a little monotonous. André writes in the morning and lunches at exactly midday, usually on a slice of ham with some peas. At six o'clock he crosses the boulevard de Clichy to go to the café Cyrano, where he joins his group of surrealist friends—Yves Tanguy, Benjamin Péret, Paul Éluard, and Wolfgang Paalen—for an aperitif. According to witnesses, these get-togethers are like rituals of allegiance to Breton. The group

discusses strategies and how to exclude heretics, and they assess the relative commitment of various individuals (Man Ray, Georges Hugnet, and Max Ernst have already left the movement). They drink mandarin-curaçao cocktails or Picon bière bitters while they pursue in-depth conversations about every aspect of life: politics, poetry, art, love, society, sexuality, rationalism, and freedom. Their gatherings are animated and last several hours. They talk about the café's customers and about ideas that crop up spontaneously, and they constantly seek out the unusual in everyday life. The same procedure is repeated day after day.

I picture Frida Kahlo, who speaks no French, joining in these discussions in which newcomers are readily put to the test. But the Mexican artist's charm operates here too, at least in the early days. The others cluster around her, bombard her with questions, and invite her to their homes. While they wait to scrutinize her work, which no one has yet seen, they comment on her sartorial originality, her magnetism, intelligence, and elegance. Frida, who has a need to please others, finds this urge satisfied in the avid attention of the young surrealists. Breton introduces her to his entourage as a surrealist painter. Try as she might to explain that she simply paints her own reality and

has no theories about art other than its sincerity and necessity, her reasoning falls on deaf ears, because, despite their apparent openness, the members of the group are incapable of grasping that she is different from them and their ideas. She is not obsessed with the workings of thought as the surrealists are, happy instead to live her life intensely and candidly. As for the revolution, she thinks people should not settle for discussing it, they should fight it.

She wrote to Nickolas Muray about this on February 16: "You have no idea the kind of bitches these people are. They make me vomit. They are so damn 'intellectual' and rotten that I can't stand them anymore. It is really too much for my character. I [would] rather sit on the floor in the market of Toluca and sell tortillas, than to have anything to do with those 'artistic' bitches of Paris."[10]

After two hours of talk at the café, Breton usually points to those he has selected to continue the conversation at his apartment. A small group of five or six people, singing and walking arm in arm, heads back across the boulevard de Clichy to rue Fontaine. They find themselves somewhere to sit, on the floor or on chairs, and

comply with their master's whims as he throws out
subjects for discussion or ideas for games: conse-
quences, portraits, Chinese whispers, or Truth
or Dare. André Breton particularly likes this last
game because participants are so defenseless and
fluctuate between revelation and evasion, laying
bare the most intimate aspects of their personal-
ities. During the course of one of these evenings,
Frida is caught in her host's trap in this way. She
has to say how old she is. She hesitates for a mo-
ment and then refuses: officially she was born in
1907, but she prefers to say her date of birth co-
incides with the beginning of the Mexican revo-
lution in 1910. Her refusal means she must face
the dare: make love to an armchair, Breton in-
structs her solemnly. Should we read into this a
wish on his part to test Frida's concept of sexual
freedom? Is he thinking of the affair she is con-
ducting with his wife Jacqueline? In any event,
Frida takes up the challenge, sitting on the floor
and sensuously caressing the chair, her mouth
half open and her eyes swooning in rapture as if
she were gazing at a lover's body. Frida Kahlo's
biographers agree that this episode was etched
into the memories of all present, but the truth
is no one has ever described in detail what hap-
pened that evening. As a general rule, Breton,

who cannot bear cigarette smoke, turns everyone out at around eleven o'clock.

Although Frida may not see herself as a surrealist artist, she is fully apprised of the advantages to be had from associating with this internationally recognized movement. She therefore does not rebel against Breton, who on the one hand validates her as an artist and on the other treats her as a pupil and gives her advice: she must go to the Louvre Museum, meet such and such a person, and have such and such an opinion. But her patience has its limits, and she hopes to move to different accommodations. Not least because she is witnessing the breakdown of the Bretons' marriage. Like Frida, Jacqueline is a free young woman, she dances exuberantly around the apartment, barefoot and cigarette in mouth. But truth be told, the space is monopolized by André. Newly acquired primitive art curios take all the available space and are destroying the relationship. Jacqueline dare not set up her easel to paint, for fear of her husband's comments.

She takes on small decorating jobs to compensate for the lack of funds, but her frustration is growing by the day and poisoning their life

together. If Frida is present when they argue, she sides with Jacqueline, who confides that they are on the brink of breaking up. Jacqueline was pregnant when they arrived home from Mexico but did not want to keep the baby. As for Frida, just as she was leaving Mexico, Diego told her he intended to divorce her because he could no longer bear her jealous outbursts. These anxieties compound the list of annoyances and concerns that she expresses so bluntly in her letters. She must live life to the fullest so as not to succumb to depression and despondency.

My father told me he knew André Breton well, but it seems the two men were not designed to get along. Although my father recognized the importance of surrealist thinking and admired the poet's books, he did not much care for him as a person. He criticized Breton's dogmatism and the way he controlled and manipulated his followers— even his friends. Frida Kahlo was most likely of the same opinion. Perhaps they talked and laughed together about the boring intellectual with the leonine hair.

My father's real friends were the dissident surrealists: Desnos, Leiris, Prévert, Hugnet, Dalí, and Queneau. In 1924 some of them had contributed to writing *Un cadavre*, in which they—humorously

but violently—denounced André Breton's "Papology," calling him a lyrical charlatan who played the part of policeman and priest. They criticized him for advocating radical surrealist acts while settling for a pathetic little life as a professional intellectual.

My father did not like recruitment, be it into the army, the church, or communism, or by Breton. He behaved like a kind of anarchist: he was everywhere and nowhere, and lived through his friendships but tolerated no constraints. I picture him as a boxer, skipping and twirling around his opponents and rivals, never quite within reach of their blows but still able to take risks out of innate nobility or for the sheer fun of it rather than for his own benefit.

THE LOVERS' MEETING

How long did Frida stay with the Bretons? Drawing on Mexican archives, Oscar has suggested three days. Martine, based on research into Jacqueline Lamba, claims two to three weeks. It might be somewhere in between, perhaps just over a week.

One bright crisp morning in February 1939, a frozen Frida alights from a taxi outside the Hotel Regina at 2 place des Pyramides, close to the Louvre. She turns to look at the gilded bronze equestrian sculpture of Joan of Arc outlined imposingly against the sky, and smiles. This figure of a

woman wearing armor like a man and intrepidly brandishing a flag rallies her courage. Jacqueline is about to step into the hotel through the revolving doors but, realizing Frida is not by her side, comes back over to her. Frida is now looking at the gold letters spelling out the hotel's name on its facade and the luxurious cars gliding past to drop off or pick up guests. She takes Jacqueline in her arms and kisses her: she is so happy to be lodging somewhere suitable at last! They enter the building like a couple, with Jacqueline holding Frida's arm. In order to stay together they avoid the revolving door and use the side door, which is opened for them by a doorman, who bows. When they arrive in the large lobby with its art nouveau paneling they start to laugh. France is so beautiful! Frida exclaims with a dash of irony, and they head for the bar to treat themselves to a morning cognac.

The room is a little disappointing, smaller than she pictured, but it is up on the top floor, the sixth floor, and has the advantage of looking out over the place des Pyramides to the front and the Tuileries Gardens on the left. When Jacqueline has gone, Frida opens her large trunk and starts putting her dresses on hangers. There is no water in the room. Frida curses. The French really are the

lowest of the low and they utterly neglect hygiene. In any equivalent luxury hotel in the United States every room would have its own bathroom, whereas here she must go out, walk to the end of the corridor, and share the one pitiful bathroom with half the other guests on the floor.

In 1999 the American art historian Nancy Deffebach asked her friend Ruth Thorne-Thomsen, who was staying in Paris, to meet my father and interview him on her behalf about the painting *The Heart*. She replied helpfully to an email from me in the early stages of my research: "It is possible that I still have an audio cassette of the interview... I will be happy to see what I can find in my archives... How lovely to have grown up with *Recuerdo* [*The Heart*]."

I was touched by this message. It to some extent *materialized* a continuity between my father and myself. This woman had good memories of him and readily passed on the results of her work to me. Other people I contacted at the same time initially replied positively, saying they remembered him as *a charming man*, but despite my repeated attempts,

they failed to respond further. These traces of the past are most likely now lost.

A few weeks later I receive another enthusiastic message from Nancy: "This afternoon I went to my storage unit and found the tape recordings of the interviews with your father . . . I think I should find a professional to convert the tapes to digital documents and send the digital versions to you." Attached to her message is a transcription of the interview in English. "I hope that this material is useful to you. It was kind of your father to be so generous with his time," she concludes.

This gesture of hers was an unhoped-for gift. The interview gives some detail about the lovers' schedules and how my father experienced this extraordinary period. In the recordings, his deep steady voice conjures his own youth and his romance with Frida Kahlo, giving me a gauge of how much she meant to him. He was fascinated above all else by her innate dignity.

How did they meet? Oscar describes my father as Marcel Duchamp's assistant; Hayden Herrera sees him as a militant Trotskyite; and the art

historian Salomon Grimberg refers to him as director of the Renou et Colle gallery.

Nancy's interview with my father sheds light on the situation: André Breton introduced Frida Kahlo to Pierre Colle, and my father coordinated the exhibition for the Pierre Colle gallery under André Breton's artistic direction and in conjunction with Charles Ratton, who had loaned some pre-Columbian artifacts. Neither Breton nor my father mentions Marcel Duchamp's involvement, but perhaps it was he who secured the release of Frida's paintings from customs, as she said in her letters.

As for Oscar, he believes my father went to pay the customs duty in person.

I do not have any information to know for sure how the future lovers actually met, but by cross-checking the whereabouts, circumstances, and personalities of the protagonists I will attempt to reconstruct the scene.

After passing the church of Saint-Philippe-du-Roule, the taxi stops at 164 rue du faubourg Saint-Honoré in the Eighth Arrondissement. The Renou et Colle gallery is housed in a Haussmann-style building.

Frida and Jacqueline enter the long thin space of the gallery. Its walls are empty. Seeing the two

women, Pierre Colle and my father break off their conversation. Colle goes to greet them, kissing Jacqueline, who takes a package wrapped in newspaper from under her arm and leans it against the wall: "The missing painting," she says.

My father shakes Frida's hand, introduces himself, and smiles as he says, "It's a pleasure to meet you, Mrs. Rivera, I've heard so much about you."

She smiles back and says, "You can call me Frida Kahlo, I'm not Mrs. Rivera here." Since arriving in Paris she has wanted to savor her autonomy as an artist.

"Frida Kahlo is a German name, isn't it?" he asks in German. "Do you speak the language?"

She replies in English, "Hitler's a pig. He's mistreating the Jews and wants to wreak havoc across Europe! I don't want anything to do with that country or its inhabitants, I'm Mexican, period—and proud of it."

Caught off guard by this impromptu riposte, he responds with clowning: he opens his eyes wide and crosses two fingers over his mouth as if barred from uttering another word. She throws her head back and laughs. Playing to his advantage, he starts making signs like those used by the deaf. She feels

she is back to her old self in this easy exchange that could go in any direction at any time, and where there is nothing at stake but the pleasure of sharing its delights with someone open and attentive. What appeals to her in my father is that he is not like the men in the surrealist clique. Besides, from their first eye contact she was aware of a physical attraction. He removes the wrapping and picks up the small painting that Jacqueline brought, holding it at arm's length to study it. Frida is gratified by the time he takes silently examining *Suicide*, the picture she completed on her crossing.

"It's really very beautiful!" he says. Then he looks her in the eye and adds, "And you are too, you're quite ravishing."

"Thank you! I'm very touched."

"Is this you that you've depicted falling?"

"No, not at all, it's an American actress. She committed suicide."

"Thank goodness! You must stay alive, Frida, we've only just met, it would be a shame . . ."

He too is under her spell. He admits to her that Pierre Colle's associate Maurice Renou initially refused to exhibit the paintings, he felt they were too intimate and might shock the public. But everything has now been arranged. He says he

likes her work because it is radical, sincere, and true to itself. From now on he will be her point of contact for the exhibition. If she has a problem or any questions it would be his pleasure to satisfy her needs. Before she and Jacqueline leave the gallery, Frida turns around, plants a kiss in the crook of her hand and blows it toward him, with her hand held out flat. Unselfconsciously, as if they already know each other and this is a lovers' code, he blows a kiss back to her. They part without truly parting, promising they will see one another again soon.

Frida will later ask Breton for an explanation of Maurice Renou's attitude. This business has depressed and angered her. The things she expresses in her paintings are not simply merchandise, as Renou believes; they are her life, the painful experiences she has had, and they are her identity, the way she chooses to show herself to the world. Saying her paintings are shocking and unshowable means thinking this of her.

Even though she feels misunderstood, she is proud to be exhibiting in a gallery that has displayed works by Dalí, Wolfgang Paalen, Max Ernst—and other "big shots"[11] in the surrealist movement.

A photo of my father from this time, when he is about thirty, reveals a good-looking man with short hair and an attractive smile. Slightly slanting eyes—probably a genetic hand-me-down from the Huns' expeditions in France—give him a degree of refinement that compensates for his bulbous nose. The way he looks at the lens suggests he is aware of his own charm. He is tall and slim, wearing elegant clothes made to measure by English tailors. His shoes are from Bunting.

When I was a child, my classmates and I had to fill in a form at the beginning of each school year, providing information about our families, and I always felt awkward—anxious even—because I did not know what to put for "Father's profession." He had worked in advertising, in agricultural policy, and as a freelance journalist, but none of that added up to a job. It was more obvious and straightforward for the others: they could put architect, doctor, shopkeeper, paramedic, mason, teacher . . . I envied them. This gray area gave me a blurry image of my father for which I later tried to compensate by learning several occupations myself, in my case ones predicated on technical skills: set designer, photographer, filmmaker . . .

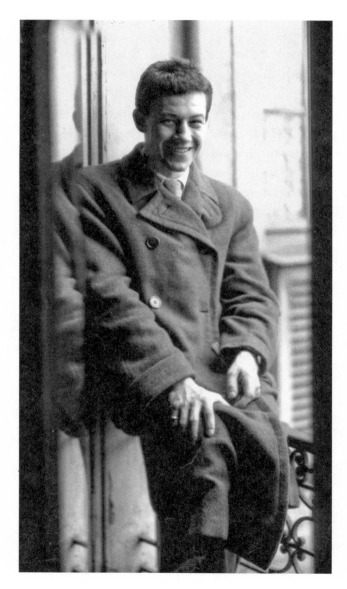

Michel Petitjean

But I did not become an architect as I would have liked.

When I embarked on writing *The Heart*, I thought that by winding back the clock and projecting myself into my father's youth in the prewar years, I would find out about his career choices and what he enjoyed doing, and come closer to knowing who he was. Did he learn a specific profession? His father, who ran a pharmacy on boulevard Saint-Marcel, had introduced him to Professor Paul Rivet. It was Rivet who first took my then twenty-year-old father to the Museum of Ethnography, where he would work until it closed in 1936. During this same period he also attended Marcel Mauss's ethnography classes at university and qualified as a lieutenant after his military officer training at Saint-Cyr. Alongside all this, he became an agricultural engineer and worked for *Le Monde* with Georges Monnet. In 1936 he joined the staff of Gaston Bergery's newspaper *La Flèche*, working as general manager and editing its agriculture section; and he also collaborated with Henri Langlois in setting up the French Cinématèque. He apparently had no aspirations for a career but wanted a dynamic life among artists, intellectuals, and

various political figures. I now understand that what mattered most to him was what he gained from contact with other people, and not any tangible output of his own.

A variety of letters and notes confirm that he started living in Marie-Laure de Noailles's private mansion on the place des États-Unis in 1936, although he gave his home address as the Charles Ratton gallery at 14 rue Marignan. That was where his mail was delivered, but he did not live there. He also still had his room in his parents' home at 26 avenue des Gobelins, and slept there from time to time. He regularly worked with Charles Ratton and was involved in the surrealist exhibitions of 1936 and 1938. In politics he was committed to Gaston Bergery's antifascist Front commun movement and called himself a Trotskyite. He started spending time with the surrealists in 1934 and called them his *family*, particularly Robert Desnos, Benjamin Péret, Yves Tanguy, Salvador Dalí, Paul Éluard, René Crevel, Georges Hugnet, André Breton, Marcel Duchamp, and Man Ray.

All these people, along with many others, attended Marie-Laure de Noailles's salons, the center of gravity for anybody who was anybody in

Paris. As the Vicomtesse's lover he was in a privileged position in comparison with the surrealist group, who constantly sought this patroness's favor.

It seems that when my father met Frida he was busy with a whirl of multiple interests, dinners, private views, political meetings, sporting pursuits, and romantic attachments.

I remember some Sunday afternoons from my childhood when my father would pace around the house quietly whistling through his teeth and then shut himself in his study for hours. He was not to be disturbed. We children wondered what on earth he could be doing. Pressed up against the door, we heard the creak of hinges and pictured him opening his old desk, where he kept his precious files.

I now think he was delving back into his prewar memories. What I took to be a form of depression was perhaps a nostalgic stroll through letters, photos, and objects that reminded him of an exhilarating past. He relived the thrilling dynamic of

days long gone spent with the greatest artists and intellectuals of his time, in wonderful financial comfort and all the nonchalance of youth.

Frida has chosen the Hotel Regina on the advice of friends in New York and of Diego, who likes knowing she is close to the Louvre, to Italian primitive art and works by Goya and Leonardo. Visiting the museum is grueling for her because of her difficulties walking. From the hotel, she has to go under the arcades on the rue de Rivoli, enter the museum, climb the flight of steps up to the *grande galerie,* and cover the length of this 120-meter room, stopping to study the paintings that interest her. She is dazzled by some of the pieces she discovers here, particularly Giotto's *Saint Francis Receiving the Stigmata* (c. 1297–99). With its four episodes in the saint's life, she perceives similarities to the autobiographical narratives in her own paintings. She is touched by the quality of the portraiture in Francesco Botticini's *Virgin and Child* (1485) and amused by Andrea Mantegna's *Triumph of the Virtues* (1502). My father, who accompanies her during these visits, suggests she use a walking stick. "I'd

rather suffer like a beast of burden than show my disability," she replies. So he offers his arm, suggesting she lean on him.

Frida Kahlo broods constantly over her correspondence with Diego. She is terribly anxious about being far from him, from the person at the heart of her entire existence; he meanwhile keeps insisting she make the most of Paris life and all it has to offer her. He advises her to be nice to the surrealists and wary of the "profiteering French." She takes on board this advice yet again, never once suspecting that he is keeping her from Mexico in order to enjoy his conquests without suffering her paroxysms of jealousy.

I imagine Frida finds her hotel room quiet, too quiet. She spends many long hours there with nothing to do, waiting for Jacqueline Lamba, my father, Marcel Duchamp, or André Breton to come and fetch her to go for a walk, to a preview, or to a dinner. Lying on her bed wrapped in a sheet, she finishes Oscar Wilde's *Picture of Dorian Gray* and copies out a passage: "What odd chaps you painters are! You do anything in the world to gain a reputation. As

soon as you have one, you seem to want to throw it away. It is silly of you, for there is only one thing in the world worse than being talked about, and that is not being talked about."

With a cigarette between her lips, she methodically tidies her trunk, sorting through the clothes that she brought from Mexico to give to Spanish refugees penned up in camps in southwest France.

To furnish this lonely time, she darns all her stockings, just as her mother taught her.

She often looks out of the window, registering the passing time, the light going down over the Tuileries Gardens, or she studies the gilded statue of Joan of Arc on the square below. Jacqueline has told her about this iconic girl's fantastical trajectory and the three injuries she sustained in battle. The arrow that drove through her chest above her left breast in Orléans immediately reminds Frida of her painting *The Heart*, in which she depicted herself shot through by the metal handrail from the trolley car. Everything about Joan's story, including her tragic end at the stake, encourages Frida to follow her model of courage and determination. She is her sister.

———

Frida spends a long time preparing herself before going out, like an actor metamorphosing and bringing to life the character she will play onstage. Choosing the right rings and necklaces is quite a ritual. She has brought with her some twenty different items of jewelry, thrown pell-mell into fabric bags, and the way she combines them depends on her inspiration that day. She uses makeup—foundation and rice powder—to lighten her dark skin. She applies lipsticks in saturated colors, bordering on magenta, and signs her letters by imprinting kisses on them in this strong red. Styling her hair is an exercise in self-control and skill to which she devotes great concentration in front of the mirror. Her long black hair is patiently combed and then braided; she adds in fine strips of blue or red fabric, either as integral parts of the braids or knotted like ribbons around Easter eggs. Other times she uses combs adorned with costume jewelry. The whole arrangement is then piled onto her head in a sort of chignon of varying heights and widths. The end result is an artistic creation that she embellishes with flowers. This is why my father nicknamed her his *maypole*.

She spends a whole afternoon in her nightshirt by the misted window, tracing shapes with a finger and softly singing a Mexican lullaby. A house, faces, trees, and an animal appear by turns on the pane. She erases them as she goes, then purses her lips and blows on the glass to create more condensation with her warm breath so she can start drawing again. Wearying of this, she sits on the carpet and spends an age combing through the long fringing on the tub chair with her fingers, as she used to at her parents' house as a child when she shut herself away in her own little world.

One of the paintings in the Paris exhibition, _Girl with Death Mask_ (1938), also known as _She Plays Alone_, features a little girl of about four, probably Frida at that age. The child, who is barefoot and wears a faded pink dress, hides her face behind a painted cardboard mask of a skull like those worn by Mexicans for the Day of the Dead, when the dead are celebrated exuberantly with parades and macabre reenactments. The little girl holds a yellow chrysanthemum, a flower often laid on graves. At her feet is a frightening sculpted wooden mask of

a tiger sticking out its tongue; it is exactly like a mask that hung in Frida's home in Mexico. In the upper half of the painting the background is a turbulent blue sky threatening a storm. Below this is a strip of desolate mountains in the distance, and they too are blue. The ground is arid but represented in warmer tones. The background is simply a buffer zone, with no promise of better things to come, no way out; there is nothing to suggest the child's circumstances might change. Is she really alive, is she really part of this world?

There are echoes of Francisco de Goya's *Procession of Flagellants* and James Ensor's *Death and the Masks*, but surely her inspiration is more likely to come from Aztec mythology, with the tiger mask representing Mictlantecuhtli, the god of death? In these myths, Mictlan is the realm of death, the lowest place, the world below; and rites associated with the myths included human sacrifices. In which case, the little girl would represent Mictlantecuhtli's wife, the "Lady of death." The legend goes that after she was born, when she was still very young, the Lady of death was sacrificed. There are several possible interpretations here. Frida may be using her painting to express what she feels in her relationship with Diego: his betrayal with her sister Cristina, the endless infidelities, the possibility that their

marriage will soon be over, and the ultimate annihilation of death. Or she could be referring to a dramatic event from her childhood that killed her psychologically. But perhaps it also evinces the idea that Diego has killed the child that she feels she is compared to him; he is older, enormous, and unreachable, both artistically and emotionally.

This painting is so arresting because it juxtaposes a child's world with the adult world in a way that implies some form of abuse, a rape, a sordid crime.

In this image, Frida's ability to paint affords her an intense means of expression for intimate concerns that she may not be able to tackle in her thoughts, in conversation, or in writing.

The power deployed in this plastic medium makes the issues explored all the stronger and more enigmatic.

THE SPANISH CIVIL WAR

In interviews my father has mentioned the date on which he first spent the night with Frida: "I remember because it was the day Barcelona fell."

It is so cold that there is a fine veil of frost on the cobblestones, the trees, and the Tuileries Gardens. The hotel staff have loaned Frida a long coat, which she has draped over her shoulders to avoid creasing her Tehuana dress. On her way out, she elegantly helps herself to a few flowers from the exquisite bouquet in reception. As soon as she is in the taxi in which André Breton has been waiting, she slips them into her hair, checking the effect

in the passenger mirror. Breton compliments her appearance but expresses his doubts about how long the flowers will last in this temperature. She is in a good mood; smoking all the while, she hums a popular Mexican song.

The taxi drops them at 11 place des États-Unis, outside Charles and Marie-Laure de Noailles's late nineteenth-century mansion. As they ascend the wide marble staircase framed by columns, she feels as if she is visiting a museum: all around her the walls are covered with historic works of art, portraits of Goya's son and daughter, a portrait of Lady Anne Cavendish by Van Dyck. These classical pieces are paired to remarkably good effect with works by Max Ernst, Balthus, Paul Klee, Juan Gris, and a bronze of the Venus de' Medici. Farther on, she walks through a sitting room graced by a Delacroix, a Chirico, and a Watteau. She does not like the rich on principle, but is impressed by the couple's taste.

They join the other guests in the small sitting room. My father, Charles Ratton, and Yves Tanguy are clustered around the radio, their faces fraught. When he sees Frida and André, my father announces in a devastated voice, "Barcelona's just fallen, it's all over!" Frida blasts her indignation in Spanish. A young man tries to find Radio Barcelona, which broadcasts on 377.4 meters (795 kc/s).

The sound of static while he searches for the frequency, then a warlike voice against a background of military music announces that the radio station has been taken over by the Nationalists.

Among my father's papers I found a menu card for a dinner at the Noailleses'. I cannot confirm that it was the one for January 26, 1939, but that is of little importance. On that evening—or another— there were a variety of hors d'oeuvres, a timbale à la Parisienne, mixed vegetables jardinière, chicken in aspic, salad, ice creams, petits fours, fruit, fine wines, champagne, and coffee.

It seems likely that conversation was entirely devoted to the end of the Spanish Civil War, and to the humanitarian disaster represented by the exodus of hundreds of thousands of Republicans to France and other countries. The end too of any hope for a popular revolution in Europe. Fascism was at work everywhere.

I have revisited a recording of a conversation I had with my father when he described his 1938 trip to Spain for the newspaper *La Flèche*:

> *I went to Barcelona during the trial of the POUM [the Trotskyist-leaning Workers' Party of Marxist Unification],*

who were falsely accused of spreading counter-propaganda
to the Russians and Communists. We'd arranged a big
meeting at the paper's offices and realized we didn't
really know what was going on in Spain. Then someone
turned to me and said, "Well, you should just go there,"
and so I volunteered. I can see myself now standing on
the platform in the underground part of Orsay station
where the mainline trains leave from. José Maria Sert
had brought parcels for me with messages for everyone.
His friends were supposed to pick me up by car when I
reached the Spanish border but they weren't there, so I
continued by train. It was full to the gunnels and under
constant fire, it was pretty terrifying. As soon as it stopped
at a station people would pile in through the windows.
They'd land in your lap with all their luggage. There was
bombing very close to Barcelona, so the train stopped
four kilometers short of the city. We had to get out and
make our own way on foot. I had a seventy-kilo bag of
provisions for friends, and I couldn't carry it on my own. I
spotted a strong-looking guy, gave him some money, and
dumped the bulk of my packages on him and took the rest
myself. Once there, it was horribly difficult to get into the
courtroom. José Maria Sert had told me to get in touch
with Jaume Miravitlles, who was a writer and a member
of the Catalonian Comisariado de Propaganda. Jaume
Miravitlles appeared in two Buñuel films, Un Chien
Andalou and L'Age d'Or. I called him and as soon

*as he knew I was in town he said, "Don't move, I'll send
a car and an escort, you mustn't walk around alone like
that." So he carted me around with him the whole time,
with armed men on the running boards of the car. In the
evenings we went to dance halls where the soldiers came
for entertainment. I did manage to get some details of the
trial, but not many. A few days later when I was leaving,
Miravitlles made sure no one knew about it. He arranged
for me to be driven to the far end of the runway and for the
plane to wait for me there. There'd be no formalities, I'd
just get on the plane. It was fun. And to make things better
the pilots were friends of Saint-Exupéry, who was part of
the French airmail service to South America.*

My father's accounts of the Spanish Civil War
are anecdotal, and the episodes he keeps in the
dark lead me to imagine more heroic events in
which he participated. I therefore always believed
he had been involved in active combat, when in
fact he traveled to Spain three times as a journalist
to gather information.

After the dinner at Marie-Laure's house, the taxi
drops Breton home and heads for the Hotel Re-
gina. Frida feels both sad and angry. She ricochets
between bouts of listlessness and sobbing, and

begs my father to do something: "We can't let these people slaughter each other." He tries to calm her by stroking her gently and talking to her but it is no good, her pain is too unbounded, feeding on older afflictions buried within this tide of emotion. He takes her head in his hands and kisses her until she relaxes.

The Spanish Civil War has been very much in Frida's and my father's thoughts for many years, even though their own experiences of it are so different. Hostilities in Spain began on July 16, 1936. Frida kept abreast of the news but became truly committed in December 1936, when a delegation of Spanish militiamen traveled to Mexico to spread word of their struggles against General Franco's supporters to their comrades across the Atlantic. Their intention was to gather funds to help anyone committed to the Republican cause. Frida attended their meetings and was touched by the mood of solidarity that the delegation roused in Mexico's workers' organizations and more particularly by the fact that, despite their own poverty, many ordinary working men offered the embattled Spaniards a day's wages.

Along with Diego, other personalities, and the organizers of the country's workers' revolutionary movements, she set up a committee to raise funds.

She was part of the "Exterior" commission that tried to secure subsidies from abroad. She set to work quickly, approaching friends and relations in the United States and asking for money to buy milk, food, and clothes for the thousands of children whose parents were fighting at the front. Even at this early stage, Frida talked of traveling to Spain. In her mind, that was where everything was playing out, the future of the whole world was being threatened by Hitler, Mussolini, and Franco. The revolution had to triumph in Spain and everyone had to take part, wherever he or she might be.

But now that she is in France in 1939 it is all over. The dream of justice and human solidarity is falling apart. Clinging to these moral and ethical values has helped Frida to contend with her physical disintegration and her emotional environment. Her commitment has been a counterbalance for her own fragility.

My father, meanwhile, had been involved in the Republican cause from the start of the war. In April 1936, when his affair with Marie-Laure de Noailles was just beginning, he told her of his political commitment. With him this aristocratic esthete

would discover "the proletariat." When the war broke out a few months later, in July, he decided to go and deliver arms to the Republicans in Spain, thinking he could sidestep the embargo that the right had imposed on the Popular Front government. It was a fanciful adventure. He persuaded Marie-Laure to go with him; they left at dawn in a chauffeured limousine with the trunk full of cases of rifles, pistols, and ammunition. Along the way, between Angoulême and Bordeaux, they had a collision with a truck. It was not a serious accident but they were worried the police would come to the scene. As they made their getaway and reached Bordeaux, they came across Georges Monnet on his way back from the Spanish frontier, and he advised them not to travel to the border because "there's firing in every direction." He told them of a drop-off point near Biriatou where they could leave their cargo.

POLITICAL COMMITMENT

When I was twenty, a few years after the up-
heavals of May 1968, I started to question the exact
nature of my father's political commitment. He
had told me little about how it evolved, but I knew it
had started in the early 1930s, when he was an ac-
tivist in antifascist leagues. It was then that he met
the politician Gaston Bergery, who represented
the left wing of the Radical Party, whose militants
were known as the Young Turks. My father worked
with him until the time of the war. They became
friends and moved in the same social, intellec-
tual, and artistic circles. Bergery, eighteen years
his senior, evolved into a sort of substitute father
for him.

In French left-wing parties emotions were running high about the rise of Hitler and fascism and about the war that threatened to engulf Europe. In 1933 Bergery and my father attended a conference held by Amsterdam-Pleyel, the first movement against fascism and the war. It was a cross-party committee that brought together many left-wing organizations and intellectuals, such as Paul Langevin, Albert Camus, and Romain Rolland. Georges Monnet represented the Socialist Party and Henri Barbusse the Communist Party. After this conference the league pooling together these parties was styled the Front commun (the Common Front). My father took on a role equivalent to secretary-general. But the Communists were keen to wrest control of the project, and the whole enterprise collapsed: Monnet returned to the Socialist Party, Barbusse to the Communist Party, and Gaston Bergery and my father set up a movement that initially kept the name Common Front before being renamed the Social Front. It had its own press organ, *La Flèche (de Paris)*, and attracted supporters such as Souvarine, Victor Serge, André Gide, Robert Aron, and Henri Jeanson, all of whom had links with the Trotskyist-leaning Fourth International.

My father admitted to me that during an anti-far-right demonstration on the place de la Concorde in February 1934 he had a handgun on him, and this made quite an impression on me because I felt it meant he had been prepared to risk his own life and other people's for his ideas. One event cropped up repeatedly in his recollections. It took place during the 1935 International Congress of Writers. André Breton was denied the opportunity to speak by the Soviet delegation, and this led to the surrealists definitively refusing to follow the Communists: Breton and Péret resolutely switched allegiance to Trotsky.

When André Gide returned from the USSR in 1936, he published a book in which he denounced the heft of bureaucracy in the country, the falsity of its collective enthusiasm, and its deliberate deindividualization of its people. Like many left-wing sympathizers, my father had become distrustful of the Communists. And then came the Moscow trials, which were instigated by Stalin between 1936 and 1938, and culminated in the execution of thousands of leading figures, Red Army generals, participants in the October Revolution, and supporters of Leon Trotsky (Stalin's great rival, who had been exiled from the USSR in 1929).

In addition to this, during the Spanish Civil War Moscow tried to take power within the Republican movement by eliminating anarchists and members of POUM. These are all reasons why on the eve of war in 1939 left-wing militants viewed French pro-Soviet Communists as their enemies. The Fourth International, which was set up by Trotsky in Paris in 1938, distinguished itself from Stalin's Third International in the USSR by bringing together millions of workers across the world with a view to launching an international revolution and emancipating working-class people. My father called himself a Trotskyite, but he was drawn not so much to a new worldwide revolutionary movement as to an anti-Soviet Communist stance. In fact, during my research I came across a file with his name on it in police archives, in which he was identified as having *progressed from Trotskyite socialism to militant anticommunism*.

Other people had a more lighthearted and amused response to my father's political commitment. In the days of the Popular Front, Jean Hugo wrote in his diary: "Marie-Laure de Noailles decrees what people are: Poulenc is right-wing, Auric left-wing, Bérard is right-wing and may even leave France. Whereas Michel Petitjean is neither right- nor left-wing, he's a nationalist."

He then adds: "There are three members of the Nationalist party, Gaston Bergery, Michel Petit-jean, and Marie-Laure de Noailles."

On the other side of the Atlantic, in Mexico, Frida Kahlo's political trajectory perfectly matched Diego Rivera's. When they met in 1928 she joined the Mexican Communist Party—he had been a member since 1921.

Mexico's President Lázaro Cárdenas, who was elected in 1934, orchestrated a real social, economic, and cultural revolution in his country; artists and intellectuals were quick to join the cause, starting with Diego and Frida. To improve conditions for the poor, the president launched ambitious agricultural reforms: the peaceful distribution of 45 million acres of land to 800,000 smallholders on the basis of collective land ownership. He nationalized the oil industry and ousted many foreign investors. Lastly, he initiated a massive in-depth program of reform and improved literacy in the education system.

Diego was one of the official painters for this Mexican revolution. His huge mural frescoes

illustrated class struggle and advocated reconcil-
iation between the elite and the people; between
Native Mexicans and Mexicans of Spanish and
creole origin. Frida may not have been as involved
as Diego was in institutional cultural programs
based on patriotic values, but with her intimist
style she redefined a national identity founded on
a multicultural Mexico. For her, Mexico's "revo-
lution" was both a reason to be and a way of being
that she incarnated and idealized.

In 1930 Diego Rivera was expelled from the
Mexican Communist Party because he was accused
of collaborating with the government by accept-
ing a commission at the national palace. Out of
solidarity, Frida also left the party. When Trotsky
came to Mexico in 1937, Diego invited him—along
with his wife, Natalia Sedova, and his escort—to
live at his house. Immediately afterward, the Rive-
ras joined the Fourth International. In response
to this happy dynamic, Trotsky wrote a glowing
piece about Diego's work:

> Diego Rivera has remained Mexican in the most profound
> fibers of his genius. But that which inspired him in these
> magnificent frescoes, which lifted him up above the artis-
> tic tradition, above contemporary art in a certain sense,
> above himself, is the mighty blast of the proletarian rev-

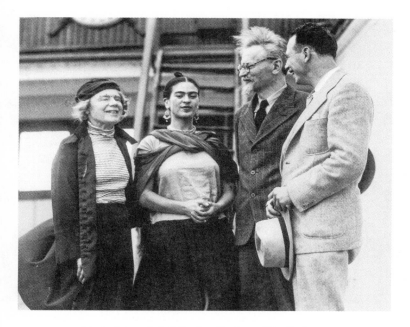

*Natalia Sedova, Frida Kahlo, Leon Trotsky, and Max Shachtman
on their arrival in Mexico on January 9, 1937.*

olution. Without [the] October [Revolution], his power
of creative penetration into the epic of work, oppression
and insurrection, would never have attained such breadth
and profundity. Do you wish to see with your own eyes
the hidden springs of the social revolution? Look at the
frescoes of Rivera. Do you wish to know what revolution-
ary art is like? Look at the frescoes of Rivera.[12]

Cárdenas announced on the international stage that he was antifascist and started sending arms to the Republicans from the start of the Spanish Civil War. When the conflict ended he took in 40,000 refugees regardless of their political leanings, and it was he who officially offered political asylum and police protection to Leon Trotsky in 1937.

In his Nancy Deffebach interview my father acknowledged how much the Spanish Civil War had meant to him and Frida. They had both been aware of the historic nature of the events unfolding around them, even though they were some distance from the Spanish border, and this brought them together. The need to act bonded them, and this mattered more to them than ideological considerations.

When she goes to the international commission helping Spanish refugees at 12 impasse Compoint, near the place Clichy, "Frida the chameleon" wants to alter her appearance: she pulls her hair right back and ties it in a braid down her neck. I can picture her at my father's side in a dark skirt and a sensible white blouse with little jewelry and a dark red rebozo over her shoulders as she steps into the

large premises that have been used as the POUM's information point since 1937. The Trotskyite POUM has contacts in the United States and England, and publishes an international bulletin called *Independent News*. Félicine Challaye, André Breton, Colette Audry, and Marceau Pivert are sitting around a table, talking. Lucien Weitz, who runs the organization, greets Frida warmly, offers her a small armchair, and sends a young boy who is sorting through posters to fetch her a coffee. When Benjamin Péret arrives with his wife Remedios Varo, they cluster around Frida. Benjamin talks passionately about his experiences fighting in the Spanish Republican army in 1936, first in the POUM ranks on the Irun front and then alongside the anarchists in the Durutti Column. The three of them speak in Spanish. Not understanding what they are saying, my father moves away and watches from a distance as Frida talks animatedly and laughs with other people. For the first time he feels she is a complete stranger to him. Their nights of lovemaking, their laughter, pleasure, and affinity seem to mean no more to her than this conversation with the Pérets. He usually takes little interest in what his mistresses do when they are not with him. Is he becoming jealous? He strolls around the office nonchalantly while he waits for

the meeting to begin, and browses through piles of variously colored tracts. What he is looking at is the manifesto *Towards a Free Revolutionary Art*, a double page written by Trotsky and Breton in Mexico in 1938 (but signed by Diego Rivera and Breton), which he has already read. He picks up a copy and reads a few lines at random: "It therefore follows that art cannot fail to be degraded if it consents to comply with any external directive and meekly fill the frames that some people see fit to assign it, in order to serve extremely short-term pragmatic ends."

He puts the tract down thinking there is something very disturbing about André Breton promoting a text on art—however revolutionary it may be—at a time when Hitler is about to start a war and Mussolini and Franco are already at work just beyond France's borders. Breton's completely missing the point! My father suddenly has an image of a runaway train hurtling through the countryside while the engine drivers play cards with the passengers . . . Everything is heading for a brick wall and no one realizes the scale of the impending disaster.

About forty people have gathered facing the tables at which the members of the committee and

Frida Kahlo sit. Marceau Pivert, the leader of the PSOP (Workers' and Peasants' Socialist Party), is first to speak: "The Spanish people have been betrayed, both by their leaders and by the Stalinists. A proletarian revolution can succeed only if the whole former system is destroyed, all class allegiances are broken down and all means of control are seized . . . Don't be disheartened by this, join the PSOP and remember our first maxim, Marx's rallying cry: *Workers of the world, unite.*"

The clapping is so effusive that my father wonders whether the audience is applauding the content of Pivert's speech or his sheer charisma. Next Frida speaks in Spanish, and Remedios Varo translates. She talks about the Mexican revolution, the project to gather funds for Spanish refugees, and the Mexican state's pledge to take in refugees. A militant who has just returned from visiting camps in southwest France describes how families are unceremoniously split up by the French police, with women and children being sent to one camp and men to another. He has with him the list of refugees in a camp in Argelès, with information about their state of health and how to prioritize helping them. At the end of the meeting, a member of the committee outlines plans to distribute propaganda postcards featuring a montage

of photographs—injured civilians, a child on crutches, and fleeing evacuees—and the words, "They are fleeing fascist barbarity...HELP THEM." Frida adds her signature to the thirty or so of other leading figures and militants.

On the Internet I found further black-and-white photographs dated February 1939. They are of some thirty people grouped around a truck on the rue Rochechouart. The gray light and the people's clothes imply that it is early morning and cold. Over the truck's tarpaulin is a banner with the words Parti Socialiste Ouvrier et Paysan (Workers' and Peasants' Socialist Party). The truck, laden with clothes and food for refugees, is about to set off for Perpignan. I have tried in vain to see whether by any chance I can make out Frida Kahlo or my father in the crowd.

Information on the refugees' health grows more alarming by the day. On March 17 Frida Kahlo gives full vent to her exasperation in a letter to her friends the Wolfes in New York: "These contemptible French have behaved like pigs with all the refugees; they're just bastards, of the worst sort I've

ever known. I'm disgusted with all these rotten people in Europe, these goddamed 'democracies' aren't worth a dime."[13]

In response to the growing crisis, Frida persuades Diego to set up a project for Mexico officially to take in four hundred Spanish refugees. Diego is to handle their passports in Mexico thanks to his connection with President Cárdenas, while in Europe Frida must raise the funds to transport the refugees by boat. She asks my father to help her, and he turns to his mentor, Gaston Bergery, who puts in an official request with the Chamber of Deputies. My father's name features in a telegram that Frida sends to her husband in Mexico. It is the only time that his name is officially associated with Frida Kahlo: "I have made friends with a deputy of Bergery's who is offering to arrange for France to pay for transporting the Spanish. Contact Gaston Bergery directly at the Chamber of Deputies or Michel Petitjean, 14 rue Marignan, for the transaction."

After Frida left France, probably because war was about to break out, my father received no further response from the deputies. Nothing was achieved by Diego either. Mexican passports were never

ESTADOS UNIDOS MEXICANOS
CORREOS Y TELEGRAFOS
TELEGRAMA

17 París vía Méx DF 23 Marzo 1939 xusie
65w diferido pd D 13,15
LC.Diego Rivera.
Palmas Núm 2 dos.VILLAOBREGON DF

Hiceme amiga Diputado Bergery ofreceme hacer necesario
francia pague transporte españoles caso gral admita can
tidad grande gente dime máxime admitiriase creo proposi
sición importantisima caso imposible respondas mañana -
antes embarqueme contesta directamente gaston bergery -
camara diputados ó michel petitjean 14 rue marignan de-
jaré Leduc encargado incluya especialmente gente andra-
de caso gral acepte transacción besos tu

 Frida..

16.31.

TODO TELEGRAMA DEBE LLEVAR EL SELLO DE LA OFICINA
LEA USTED EL REVERSO: LE INTERESA CONOCER LOS DIFERENTES SERVICIOS QUE LE OFRECE EL TELEGRAFO.

Telegram sent by Frida Kahlo in Paris to Diego Rivera, March 23, 1939

issued for the four hundred refugees, and the
project fell apart.

While Frida is in Paris, Diego Rivera goes about set-
tling his accounts with Trotsky in Mexico. He
claims there has been a misunderstanding on the
subject of a correspondence with André Breton,

but in fact he is having his revenge for the idyll between Trotsky and his wife that he witnessed in 1937 and that, unfaithful husband though he himself may be, he cannot accept. He asks Trotsky to leave the blue house. Frida will second this.

Frida confides to my father that she loathes Trotsky. She thinks him a rather disgusting old man with wandering hands. She does not hate him as a person but hates the affair she had with him. She is wildly admiring of the founder of the Red Army, the key player in the October Revolution and the historian, and would in all likelihood be happy with a platonic relationship, but it was just as it had been with Diego: she was abused by a man whom she saw as a father figure, a guide, a reference. He wanted sex and that did not trouble her, even though it was not what she wanted. But perhaps in the back of her mind there was also an urge—however conscious or subconscious it may have been—to have revenge on Diego.

SUFFERING

Hotel Regina on the morning of February 2, 1939. Frida is in bed, paralyzed by pain. She has not slept all night. Her back is inflamed, and this agony is coupled with a high fever. Lying alone in the dark she tries to understand the origins of this new suffering. She contemplates each of her organs in turn, then the structure of the adjacent bones, hoping to associate them with symptoms she recognizes or has heard described: her heart, liver, intestines, kidneys, spine...She explores her stomach, ribs, and back by exerting gentle pressure with her hands. The fact that she cannot precisely locate the seat of the problem frightens her. She tenses, and this aggravates the pain.

When she is still lying there several hours later, her awareness that she is trapped in a hellish cycle produces a feeling of claustrophobia that triggers a brief panic attack. She sweats copiously and her breathing accelerates, she is short of breath, her mouth falls open, and her eyes sting. Only exhaustion allows her to relax her terror just enough to call Jacqueline.

It is eight o'clock in the morning when the American hospital's ambulance crew emerge from the hotel pushing Frida Kahlo in a wheelchair toward the ambulance parked on the taxi rank. Looking dignified and with her head held high, Frida is keen to show curious passersby that there is nothing wrong with her and they need not look. Jacqueline sits next to her in the ambulance, lovingly holding her hand on the trip to Neuilly and describing the world outside: the rue de Rivoli, the place de la Concorde, the Champs-Élysées, and the avenue de la Grande-Armée. She tries to keep Frida entertained with nursery rhymes. By the time the ambulance starts to climb the rise toward the emergency room on the boulevard Victor in Neuilly, Frida's cheerfulness has been restored, and she humorously berates this wreck of a body with which she somehow has to get through life.

The brick-built six-story building occupies a small block and has 120 beds. The hospital was established at the turn of the twentieth century with the aim of providing people from the United States, be they resident in France or simply visiting, with doctors trained in America. Members of royal families, diplomats, artists, military figures, students, and businessmen receive treatment in this establishment, whose excellent reputation reaches way beyond France thanks to its competent, attentive, English-speaking staff. Frida instantly feels safe here. After some tests and an x-ray, the doctors diagnose a kidney infection.

The way Frida describes her illness in her letters varies according to the addressee. In her letter to Muray of February 27 she very unfairly blames the Bretons for her condition, railing about how dirty their apartment is and how unhygienic their food. When she writes to Bertram and Ella Wolfe on March 17 she adopts a humorous tone, comparing the bacteria hidden inside her to anarchists armed with bombs. As for Diego, she decides not to tell him anything so as not to worry him.

As she does in her paintings, Frida feels a vital need to identify and openly name her own personal stations of the cross.

One afternoon in the hotel, she is lying on her back naked on the bed with her hair fanned out around her face and resting her head on one arm. My father is sitting on the edge of the bed looking at her. She responds to his gaze: "I'm ugly, a walking disaster, my life unfolds as if I should never have existed."

She then gives him a playful topographical description of the damaged parts of her body, pointing to each scar in turn: "When I was six this foot was hit by a piece of wood and that gave me goddamn polio which is why my leg is all skinny and too short. At school they called me 'crazy foot' and 'the limper'—it was the shame of my life, I could have killed all those little bastards who made fun of me! Later I had several operations on the foot, followed by months of convalescence. Look, they cut off three of my toes. Last year in New York I had an ulcer as well as huge corns on the soles of my feet, it was hell, I couldn't walk! . . . After that came an accident when I was eighteen. A trolley car ran into the bus I was on and that ended up with me naked as I am today covered in this golden powder that one of the passengers was carrying. A

metal handrail had gone right through my body. It went in at the back, here." She rolls over to show him the scar on her left hip. "And it came out through my vagina, here."

The accident caused fractures to several vertebrae, her pelvis, and her right foot. The abdominal injury, where she was punctured by the handrail, caused acute peritonitis. She had to wear a full body cast for months. Her general health did not recover with passing years; she underwent many painful operations that necessitated long periods of bed rest. She also complained of chronic fatigue and pain in her back, legs, and feet until the end of her life.

My father was probably very sensitive about Frida's pain and her disability. He used to speak with great emotion and empathy for his sister Thérèse, who was two years his senior and contracted tuberculosis. She would spit blood when she coughed. Because their parents were at the opera that evening, he was alone at her bedside on the night that she died in his arms. He was fifteen years old.

He also told me that when he returned from captivity in Germany in 1945 he had gone to recuperate with friends in Fontainebleau. While there he witnessed one of the famed outbursts of anger toward women suspected of "sleeping with

the Germans." Three women with ashen faces and bowed heads were jostled and insulted by the crowd and their heads were then publicly shaved, their hair falling to the ground, their scalps laid bare. Disgusted by the humiliation meted out to these women, he intervened. The emotion in his voice when he described this episode to me—I was about twelve at the time—had a profound effect on me.

After this I noticed that in any given situation he always took the women's side, whether to defend their dignity or alleviate their suffering. Perhaps this is why he was touched by Frida Kahlo's painful ordeals.

In his letters he was always very protective toward her: "I hope you're feeling better and are taking good care of yourself," "Look after yourself," and, after she left for the United States, "I'm so worried you'll have problems again as you did in Paris and you'll be in pain again like a poor shaky little leaf."

Like other children all over the world, Frida noticed from her earliest days that when she was sick her parents, sisters, and friends looked after

her, surrounded her with affection, and gave her presents, which made her feel alive and loved and that the world revolved around her. She went on to make abundant use of this form of emotional dependence related to sickness to remedy her depression, her feelings of inner emptiness, and her chronic pain, but also to satisfy her narcissistic impulses.

The trolley car accident changed her whole experience of the world: "Now I live in a painful planet, transparent as ice; but it is as if I had learned everything at once in seconds. My friends, my companions became women slowly, I became old in instants and everything today is bland and lucid. I know that nothing lies behind, if there were something I would see it."[14]

Suffering had therefore defined a new dimension of her personality. Once Frida learned to cope with it, it gradually became a new purpose in her life.

After the accident, while she was condemned to months of bed rest, she decided to paint as a way of passing the time. She took some of her father's oil paints, and her mother set up a special little easel on the bed so that she could work lying down.

Later she asked for a mirror so that she could make self-portraits. Painting was a way of exalting her suffering. It expressed what she felt, what she was going through, and the causes of these experiences. But even before the accident her career plans had revolved around both the medical world and drawing. She had intended to study medicine and become an illustrator in medical histology. As a schoolgirl she had already loved her anatomy classes; it was the only subject at which she worked. Now she would give a platform to her suffering, illnesses, and obsessions, not only through painting but also through her writing and her life.

Among my father's papers I found an article by the American art historian and psychiatrist Salomon Grimberg[15] that provides an interpretation of the painting *The Heart* by referencing the transverberation of Saint Teresa of Ávila: "her heart transpierced by the dart of divine love." For Frida this mystic image may have been a recollection from her childhood or an imagined source of resilience to transcend her pain. The painting brings together the causes of her various forms of suffering and the means—through the love of God—to find comfort; and this suggests there was a therapeutic dimension to Frida's painting. The angels on the ends of the metal rail that cuts

through her chest are reminiscent of the angels in the Ludovicus painting in the collection at the Frida Kahlo Museum in Mexico City, *The Transverberation of Saint Teresa* (1629), in which Teresa's heart is pierced by an angel and emits ardent flames.

The saint's autobiography gives an idea of her suffering and its attendant mystic pleasure:

> *I saw in his hand a long spear of gold, and at the iron's point there seemed to be a little fire. He appeared to me to be thrusting it at times into my heart, and to pierce my very entrails; when he drew it out, he seemed to draw them out also, and to leave me all on fire with a great love of God. The pain was so great, that it made me moan; and yet so surpassing was the sweetness of this excessive pain, that I could not wish to be rid of it. The soul is satisfied now with nothing less than God. The pain is not bodily, but spiritual; though the body has its share in it, even a large one. It is a caressing of love so sweet which now takes place between the soul and God, that I pray God of His goodness to make him experience it who may think that I am lying.*[16]

The Heart is a concentration of the key characteristics in Frida Kahlo's art and her biography:

intimacy, identity, physical and psychological suffering, references to Mexican culture, and references to art history.

While she is in the hospital my father, who travels a good deal, sends her a postcard with a picture of an oratory in the mountains on the Côte d'Azur. The photograph is of Baruzzi-Ostal and the card is dated February 19: "Hello Frida, look how beautiful this region is, the sun's shining the almond trees are in blossom I'm sure you'd love it, it's as beautiful as Mexico. I hope you're feeling better and you're taking good care of yourself. I'm so happy I'll be seeing you tomorrow. In the meantime here's a kiss for you. Michel."

On Charles Ratton's letterhead he sends another card with a little drawing: "Hello Frida, here's a kiss for you. Am. Express are closed because it's Shrove Tuesday. Kisses. Michel. Enclosed our little Mayan friend."

In 1939 Shrove Tuesday falls on February 21. This means he writes the card two days before Frida comes out of the hospital and it probably relates to a payment sent by Diego to cover the cost of her hospitalization. Pablo Picasso, Dora Maar, Jacqueline Lamba, André Breton, my father, and

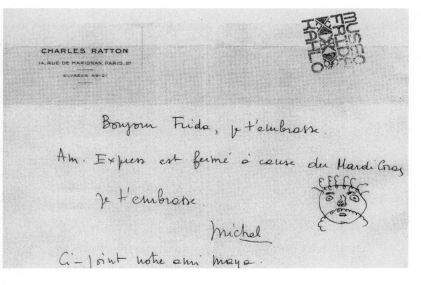

Card from Michel to Frida, February 1939

the Duchamps often visit Frida while she is in the hospital.

Picasso met Diego when he stayed in Paris during the 1910s and 1920s. Knowing Frida is in Paris, he comes to see her several times and as a token of his friendship he gives her a pair of gold and tortoise-shell earrings representing tiny hands. One time he and Dora Maar teach her a Spanish ballad, "El Huerfanito" (The Orphan), which begins:

I have neither father nor mother to suffer my pain,
I am an orphan.[17]

This very poignant song resonates profoundly with Frida's feelings of loneliness and despair. Its repetitive melancholic melody stays with her, and on her return to Mexico she will often sing it to Diego and her friends.

Where there is sickness and suffering, death is never far away. Frida uses all her energy to ward it off with a stream of drinking binges, love affairs of varying durations, passionate friendships, and political fervor, but she knows that death still lies in wait for her and will not leave her be. This preoccupation appears in one of her self-portraits, *Self-Portrait, Very Ugly*, painted in 1933. Diego Rivera suggested she try her hand at frescoes, and this picture is the result of her experiments. Disappointed, she threw the painting away; it was salvaged by a friend, Lucienne Bloch. The image is reminiscent of Fayum portraits from Greco-Roman Egypt. These very realistic representations of the dead were painted on wood and were placed over the subject's embalmed mummy. The artist painted the portrait during the subject's lifetime. "The two of them,

living at that moment, collaborated in a prepara-
tion for death, a preparation which would ensure
survival. To paint was to name, and to be named
was a guarantee of this continuity."[18]

In *L'apostrophe muette*, Jean-Christophe Bailly
suggests that these Fayum portraits were first ex-
hibited in the subject's home during his or her
lifetime before being affixed to the mummy and
sealed in the tomb.

Frida Kahlo painted some forty self-portraits, all of
them hieratic. It is not unreasonable to speculate
that, in the spirit of Fayum portraits, the purpose
of Frida's self-portraits is to celebrate her life in
anticipation of her death. In these paintings Frida
directs her more or less absent gaze at the viewer,
her face impassive. What is more, when she puts
herself into broader images alongside other nar-
rative elements, her expression does not vary. She
seems to be witnessing her own death, with all the
energy of life and creativity, but also an element of
resignation.

The painting Henry Ford Hospital (1932) was included
in the *Mexico* exhibition at the Renou et Colle

gallery. An apparently weightless bed is placed diagonally across the center of this image. Frida Kahlo lies on the bed naked with a distended stomach, and there is a large bloodstain under her. Her left hand is close to her stomach and holds three red threads that represent arteries and connect six objects. These objects also seem weightless and are arranged symmetrically, with three above and three below the bed. Those above are, from left to right: an anatomical torso, a human fetus in a posture used in ancient sculpture, and a snail to indicate how slowly she acknowledged the nonviability of the fetus. The objects below the bed are a sterilizing unit, a wilted orchid flower, and a figurative representation of her damaged pelvis, the reason she was unable to have a child. The abstract background is divided horizontally into two equal halves. The lower half is a homogeneous dull color, with a fine line on the horizon suggesting a distant industrial area; and the upper half is a washed-out blue sky.

In 1932 Frida Kahlo accompanied Diego to Detroit, where he was completing a commission, painting a mural for the industrialist Henry Ford. She was pregnant. Her pregnancy would not reach full term; she lost the baby. Between 1929 and 1933 she had three failed pregnancies, which was a source of despair to her, giving her a very negative

self-image and therefore aggravating her depression. Jacqueline Lamba claimed that Frida kept the fetuses of her dead children in jars of formalin in a wardrobe.

Marcel Duchamp and his partner Mary Reynolds often visit Frida in the hospital. Mary speaks English with Frida and reads her poems by one of her favorite writers, Walt Whitman:

> *I keep as delicate around the bowels as around the head and heart,*
> *Copulation is no more rank to me than death is.*
>
> *I believe in the flesh and the appetites,*
> *Seeing, hearing, feeling, are miracles, and each part and tag of me is a miracle.*[19]

Mary grows fond of Frida and invites her to spend her convalescence at her home. Frida falls under the spell of this tall, slender, elegant, and gentle woman sixteen years her senior. In letters she refers to Mary as *a wonderful American*. Touched by the passion between Frida and my father, Mary suggests they both move into her house, and she meanwhile will go away to the country.

THEIR LOVE AFFAIR

In the four-page document that Oscar gave me when we first met, he referred to papers of my father's in Frida's archives in Mexico. My plans to travel there to consult them grew increasingly hypothetical, so Oscar agreed to send me photocopies of them: thirty or so pages of notes, cards, and letters sent to Frida Kahlo by my father, and three photographs of him that I had not previously seen. These documents helped to conjure something of what they shared in Paris, but what is missing is Frida's voice, her writing in the context of her relationship with my father. This absence makes her all the more enigmatic, in herself, her expectations and concerns, and how she behaved in love.

The "*idyll*" in the romance between my father and Frida takes place when she is discharged from the hospital and they move in to Mary Reynolds's home, a delightful house on the rue Hallé, very close to Denfert-Rochereau Métro station. The straight line of this quiet street is interrupted by a crescent around which some ten houses and two- or three-story studios are huddled. At number 14 a gate in the wrought iron fence opens onto a garden.

Frida Kahlo and my father have barely set foot inside the house before Mary's cats—Miki, Marce, and Mildred—come running over to them, mewing and purring as they wind themselves around their legs and under Frida's long skirt. She tries to pick them up but they dart away and back again too quickly: they have appropriated her. The couple walk down a corridor and come to a large room where Mary is sitting in an armchair reading. She gets up to give each of them a heartfelt, unselfconscious hug. Frida, who is still a little pale, says how happy she is to be here. Mary takes one of Frida's hands and one of my father's in hers and smiles at them warmly, looking them in the eye, first one,

then the other. Next she takes out a bottle of port and three glasses, and they drink a toast proposed by Mary: "To all the years we have left—to live." The dinner they have this first evening is very exuberant and well lubricated in Frida's honor, attended by Marcel Duchamp, Georges Hugnet, Valentine Hugo, and Jacques Villon.

Apart from my father, everyone who comes to the dinners at the house on the rue Hallé speaks English. He used to justify this shortcoming by saying that when he was nineteen he was adopted by the gang of Americans in Paris: Monroe, Powell, Hemingway, and the Canadian Calder. They all refused to speak English with him, claiming they were practicing their French. "The only words of American I learned were the slang that Calder taught me. So I just remained their French teacher. As soon as I said anything in English they made so much fun of me—and anyway, I was very lazy," he admitted, laughing.

One way and another, Mary Reynolds's house reminds Frida of her own home in Mexico. Instead

of spider monkeys and little hairless dogs there is a gang of free-roaming cats. Instead of the architect-designed house in San Angel, a small house with a garden to the front and rear. The open-hearth fires warm her body and soul. The library, Mary's bookbinding workshop, and the paintings on the walls make Frida feel she is somewhere familiar, a place dedicated to intelligence, art, and life. My father—an elegant, sporty figure—busies himself around her. He is in love, he shows her around Paris and plans outings. She is surrounded by people who appreciate her and value her, and she soon recovers her center of gravity.

Frida and my father often go to the cabaret bar Le Bœuf sur le Toit, on the avenue Pierre-Iᵉʳ-de-Serbie. Rather than the dance hall with its band on the second floor, they like the cozy top-floor bar. This establishment, which has drawn every mover and shaker in Paris since the 1920s, is not frequented by the surrealists on the express instructions of André Breton, who does not want to mix with the group that includes Jean Cocteau, who launched the venue. My father told Nancy Deffebach about a wonderful black pianist, Garland Wilson, who accompanied Nina Mae McKinney, an actress and singer who appears in King Vidor's film *Hallelujah*. "She was ravishing: huge intense

eyes and a dazzling smile. The atmosphere was very muted, very gentle, very sensual. Frida would sit next to Garland at the piano. We chatted and he played anything we asked for. She dressed so beautifully for those evenings. She had stunning earrings shaped like vases, very heavy ones made of jade, and we used to put orchids in these vases. They were the most extraordinary pieces of jewelry. People at Le Bœuf sur le Toit would go down on their knees before Frida," my father recalled.

I imagine it is cold in Mary Reynolds's house. They set up a makeshift bed by the fireplace, where they keep a fire roaring the whole time, my father feeding it with great moss-covered logs.

Here on this bed they make love, drink, eat, sleep, smoke, and spend long hours talking and listening to music. They are not apart for a moment and go out as little as possible, and this brings them together in a deep yet lighthearted intimacy. They know they can tell each other anything, and it will never go any further.

One evening Frida turns out all the lights and slips out of the room, draped only in a floaty

magenta-colored rebozo. He sits with a cigarette in his mouth and a glass of wine in his hand, hypnotized by the fire in the hearth, which lights the room with its glow and projects flickering shadows on the walls. Frida returns dressed as a man: Prince of Wales checked pants with darts, white shirt, and blood-red vest and tie. Her hair is drawn back and fastened with a ribbon, and she has accentuated the fine hairs on her upper lip with coal dust. She smokes and dances like a man, guiding an invisible female partner.

She tells him that before she was born her mother, Matilde, had a baby boy who died of pneumonia when he was a few days old. Her parents, who already had two daughters, had longed for a boy, and so Frida's identity was established in the shadow of this dead brother. Perhaps, in order to grow up surrounded by her parents' love, she tried to satisfy this longing of theirs by offering them, insofar as she could, the image of the son they had lost. Living with a borrowed sense of "me" implied surrendering her aspirations as a little girl.

As early as elementary school she was a tomboy, and people would say, "That Frida *is* a little strange." She careered around on skates and bicycles. As a teenager she started behaving like a

boy: "I dressed like a boy with shaved hair, pants, boots, and a leather jacket."[20] Frida's father pinned all his hopes on her; he imagined her becoming a doctor. Her sisters were beautiful and Frida was intelligent, so he hoped that she would realize the ambitions he had nurtured for his son. She succeeded in being accepted by a group of politically committed dilettante students, *Los Cachuchas*, who admitted almost no women. Like them, she wore a brown checkered beret and used coarse language. Years later she would acknowledge that the shape of her face and her mustache were like a man's, as if these elements of masculinity had a stake in who she was. She felt a sort of uncertainty, a doubt about her existence, which first manifested itself in this blurred identity. As she reached adulthood, she used her pronounced mustache to assert a virile personality linked to the revolutionary figure Emiliano Zapata, thereby confirming that she wanted to be associated with this hero who championed the peasants' struggle and recognition of Mexico's indigenous peoples.

Frida's father, Wilhelm Kahlo, was the son of a jeweler who lived in Baden-Baden in Germany and whom Frida maintained was of Hungarian descent. At twenty-one he emigrated to Mexico

and Hispanicized his first name to Guillermo. He worked in the German community as a cashier in a glassware shop, as a salesman in a bookshop, and for a jeweler. He married a Mexican woman, María Cardena, who died giving birth to their third child. He then married Matilde Calderón y Gonzáles, the daughter of a Mexican photographer. Some of Matilde's forefathers were Native Mexicans. Before she met Guillermo she had been married to a German who took his own life in front of her; she never recovered from this. Matilde was illiterate and adhered to Roman Catholic traditions. It was she who urged Guillermo to become a photographer, like her father. Guillermo was a Germanophile who read Schopenhauer and played Beethoven sonatas on the piano alone in his study. He taught Frida to speak German, to paint, and to take photographs while Matilde ran the household and ensured that her daughters were brought up as strict Catholics. According to Frida, her parents did not love each other and did not get along. They developed parallel lives under the same roof, each with his or her own neuroses. On top of this, both were prey to unpredictable epileptic fits. As a child, Frida had to follow her father in the street so that she could help him if he had a seizure. We

can only imagine the anxiety that this responsibility must have fostered in her.

Losing her son and giving birth to Frida were difficult ordeals for Matilde, who then succumbed to a bout of depression. After the birth of Frida's sister Cristina, Matilde could not cope with eleven-month-old Frida and handed her care over to a Native Mexican servant who nursed her. A year later Matilde discovered that this servant was alcoholic, and she took Frida back from her. In *My Nurse and I* (1937), a painting shown in Breton's exhibition, Frida revisited this period of her life some thirty years later, demonstrating that it still obsessed her.

In this painting Frida depicts herself with the body of a baby and an adult's face, in the arms of a robust dark-skinned woman whose face is masked. The woman has one normal breast and one plantlike breast with branching systems reminiscent of milk ducts and the veining on leaves. Milk flows from the breasts. The background features dense Mexican vegetation and a sky laden with clouds raining down not water but droplets of milk.

The image references Christian portrayals of the Virgin breastfeeding, and Frida saw the raindrops she painted as the virgin's milk. But many elements in the painting refer more widely to the nurturing earth. The Aztec mask, the presence of vegetation, and manifestations of weather around Frida Kahlo express the permanence of indigenous civilization and the force of nature. The child-adult in her christening robe represents the passage of time and the transformation of the individual. This concept is endorsed by two small creatures camouflaged in the vegetation: to the left of the two figures there is a stick bug, which, unlike many other insects, hatches in its adult form; to the right is a butterfly emerging from its chrysalis, a process that the Aztecs believed gave living form to the dead. It is a symbol of death and rebirth, and therefore of transformation.

As in *The Heart*, Frida portrays a part of her life journey in the form of a symbolic image that describes the continuity of life. In this instance she includes memories of her indigenous Mexican forebears and the enduring qualities of the natural world. Painting allows her to give concrete reality to her life and a unity to her disparate sense of self.

Frida likes wandering around Mary Reynolds's home naked and with her hair loose, wreathed in the smoke of a cigarette on which she inhales greedily with her fingers tight up against her lips. She often comes back to a Man Ray photograph hanging in the living room, showing Marcel Duchamp dressed as a woman, with makeup, a necklace, a hat and coat. She is fascinated by this image, called *Rrose Sélavy*, particularly since Duchamp explained it to her. Rrose Sélavy was Duchamp's female alter ego. To French ears, the name Sélavy sounds like *c'est la vie* (that's life), and the name Rrose is very close to the word Eros, so the name has resonances of the phrase *Eros c'est la vie* (Eros is life). Duchamp chose the name Sélavy because it has connotations of Jewish inheritance, and the double *r* in Rrose is a nod to the double *l* in some Welsh words and names, such as Lloyd. This way of questioning identity and gender resonates with Frida and feels somehow familiar and enigmatic. She realizes that this idea of multiplicity can be found in her own work, particularly in her self-portraits. She plans to start work on a painting when she returns to Mexico; she will call it *The Two Fridas*, and it will

rework elements from *The Heart* with a European Frida and a Mexican Frida.

My father was particularly aware of the two cultures within Frida: "A degree of rationalism, due to her German heritage, grew more complex when it was combined with Mexican exuberance, Mexican generosity, and Mexico's colorful religious fervor. Frida was all this rolled into one." She was completely Mexican and German. It fascinated him.

I try to picture the evening when the lovers first go into Marcel Duchamp's bedroom, to the right of the front door on the ground floor. When Mary showed them around her home she said, "This is *very much* Marcel's room." Her clarification was dissuasive, no one ever opens this door. But they have no taboos, and after a few days they decide to infringe on this custom. Is it my father who turns the handle and opens the door? Are they holding hands? The light from the corridor does not illuminate much. They advance by candlelight, whispering. In one corner stands an iron-framed single bed. The walls and ceiling are entirely covered with strange wallpaper. As they come closer, they can see by the light of the

candle that it is in fact made up of dozens of road maps laid side by side, turning the room into a single enormous and improbable country. Some roads are matched up from one map to the next, establishing a continuity between the southwest and the north of the country, between Brittany and the Paris region, and between the southeast and Franche-Comté. They lie on the bed and gaze up at this extraordinary network of roads on the ceiling as others might lie on the grass in the countryside on a summer's evening and look up at the stars in the Milky Way. They recite the names of towns as their eyes alight on them, playing on the musicality of each name as they say it: Diii-jon, Reimmms, Le-Puy, Mars'eille, Vii-llee-fraanch-chee, Berk'Plaaage, Re-mi-re-mont, Florac', Caaastres, Decazzzeville, Mont-bé-liaaard, Fooorbaach, Ageeen, Foi'xxx...

How do the lovers communicate, given that they do not speak the same language? In an interview in 1979, my father gave a charming answer to this question: "The truth is Frida and I didn't really need to understand each other with words. We had so many ways of understanding each other without getting tangled up in words. We were alone together a lot

and we were never restricted by language prob-
lems. She was someone who knew what I wanted to
say before I even said it."

They go for walks together in the French
countryside. I know that my father, who studied
to become an agricultural engineer, liked the nat-
ural world. He adored skiing, and his pharmacist
father had passed on his knowledge of plants to
him. Perhaps he wants to share his appreciation
and know-how with Frida:

> *I took Frida out into the French countryside twice.*
> *She was both very captivated and very surprised. This*
> *landscape was so green, so cheerful with its little villages*
> *clustered around their churches, it felt like a completely*
> *different world from the one she knew. Our first outing*
> *was along the banks of the Seine, working our way up to*
> *Vernon, and another time we walked along the Loire. To*
> *her, France felt very faraway, not just the countryside,*
> *but the people and Paris. She really felt out of place.*

Their affair is interrupted by periods when
my father travels around the country, as proved
by three postcards that have been found. There
is one, for example, from February 19, 1939, fea-
turing a Dahomeyan sculpture. On the back is
the caption "Sculpted wooden goblet depicting a

woman playing with a little girl," and these words from my father: "Hello Frida, sending you a kiss before I leave. *For strong-arm politics.* Be good and look after yourself. With love, Michel."

An undated letter on the Hotel Regina's letterhead and therefore from before the lovers moved into Mary Reynolds's home, gives an idea of their outings:

> *I don't have a private telephone, Frida! Good morn-*
> *ing, Joan of Arc, it's sad not seeing you. There were lots*
> *of projects to talk through. Would you keep tomorrow*
> *lunchtime and Thursday lunchtime free for me. After*
> *lunch tomorrow we could go to see your paintings (at*
> *about two o'clock) and I'll leave you at Breton's place*
> *to wait for Mr. Duchamp. On Thursday I'll try to get*
> *Bettina to join us for lunch and you can go to Schiapa-*
> *relli with her. And we'll meet at about ten on Thursday*
> *evening at the Agnès Capri cabaret. I'll call you at*
> *ten tomorrow morning and I'll pick you up at 12:30.*
> *Sending you kisses, Frida. With love, Michel.*

My father did not have a private telephone. Does his choice of wording mean that he could not—or did not want to—call her? I imagine, but I may

be wrong, that he had not told Frida he was living with Marie-Laure de Noailles. He had a large bedroom with five windows in her mansion, the very same room in which Kurt Weill had stayed when he fled Nazi Germany in 1933. There was still a white Steinway piano in the room as a memento of the composer's time there. My father had an elderly, exquisitely trained servant at his beck and call.

It is most likely André Breton who first brought Frida Kahlo to the Noailleses' home. She went to place des États-Unis seven or eight times. Marie-Laure spoke very good English, which made it easy for her to form a friendship with Frida. She held two or three dinners or small receptions for her, during which she introduced her to Tanguy, Péret, Max Ernst, Henri Sauguet, and perhaps Balthus.

Does Marie-Laure know about my father's relationship with Frida? He is clearly being unfaithful to her, but this may not matter to either of them.

Frida Kahlo's biographers have said that the fashion designer Elsa Schiaparelli was so taken with Frida's clothes that she designed a dress called "Madame Rivera." My father's message to Frida

certainly implies that he arranged for her to meet Elsa Schiaparelli through Bettina, the American wife of his friend Gaston Bergery. Bettina was Elsa Schiaparelli's star model and also her right hand. My father later recounted to Nancy Deffebach that "Frida met Schiaparelli; she was a great friend of mine. We saw each other a lot, it was like family . . . Elsa really liked Frida's princely quality, the way she held herself. From a fashion point of view, it was wonderful. It was so beautiful, so coordinated. Elsa was fascinated by all her old jewelry with gemstones."

Schiaparelli had made a particular color fashionable, it was what she called "shocking pink." Misinformed journalists presumed that she had been inspired by the magenta of Frida Kahlo's rebozos when she came up with her shocking pink. The colors Frida used were typically Mexican, although the dyes were in fact invented in France in 1859 and were given the names of battles—Magenta and Solferino—fought in that same year.

It is worth trying to picture Frida and Bettina arriving outside the Hôtel de Fontpertuis at 21 place Vendôme, where the House of Schiaparelli occupies ninety-eight rooms over five floors. Bettina,

a glorious, tall, slim, blue-eyed blonde, is wearing a long dark blue coat with red lapels dotted with yellow and blue beads, and a red hat shaped like an upside-down shoe. Frida in her Mexican outfit looks almost ordinary in comparison.

They walk past the shop and go through the impressive front door to reach the second floor, where Elsa has her office. On the landing Bettina stops in front of a mannequin wearing a Harlequin coat from the Commedia dell'arte collection. She takes Frida's arm and explains that "Schiap" wants women to wear theater costumes in public to assert their independence and advocate their freedom elegantly yet provocatively. Frida wonders whether Bettina is drawing parallels between her own dress and the Harlequin outfit. She interprets the costume's diamond shapes as a representation of the multiple facets of the character's personality, but also of poverty, with its patchwork of different fabrics. She is also reminded of Picasso's *Harlequin*, which she loves.

Bettina introduces Frida to Elsa in a voice that has her usual cocktail of urbanity and slight irony: "Madame de Rivera, a friend of Michel's. Her paintings are being exhibited at Renou et Colle."

Elsa studies Frida pointedly and a little coolly, but still compliments her on her jewelry and—ever

the businesswoman—asks a few self-interested questions about their provenance. They are served tea on a low table by a window that looks out over the Colonne Vendôme. Schiap shows Frida some photographs from her collection and Frida is amused by the audacity of her dresses and accessories.

A rebel brimming over with imagination, Elsa Schiaparelli is the queen of Paris fashion, combining extravagance and class, inventing a pullover with trompe-l'œil stitching to produce a skeleton motif, broken hearts, or tattoos; designing jupe-culottes (divided skirts), which caused a scandal in England; and inventing the "mad cap," a small knitted cap in an endless variety of shapes. It was for Schiaparelli that Elsa Triolet designed the "Aspirin" necklace using porcelain beads. She collaborated with Salvador Dalí, Meret Oppenheim, and Jean Cocteau, and launched the perfume Shocking with a bottle designed by Leonor Fini that represented a dressmaker's dummy with Mae West curves—in other words, a creation that made her more a plastic artist than a traditional fashion designer.

After this first meeting the two women kiss goodbye and, in a rush of creative enthusiasm, Elsa suggests that she must design a dress inspired by Frida's very distinctive Mexican look.

In a notebook Frida makes a note of one of the
Twelve Commandments for Women decreed by
Elsa Schiaparelli: "Never fit a dress to the body,
but train the body to fit the dress." When they part
on the landing, Elsa promises to come to the pre-
view of the *Mexico* exhibition.

Rumors of a Madame Rivera dress originate
from a sentence of Diego Rivera's that was pub-
lished in *Time* magazine on May 3, 1948: "His wife
and fellow artist, Frida Kahlo, said he, has worn
nothing but Mexican clothes for 22 years, and when
she went to Paris in 1939, Madame Elsa Schiapa-
relli was so impressed that she designed a 'robe Ma-
dame Rivera.'"[21]

Intrigued to find out about this much discussed
dress that no one appears to have seen in photo-
graphs, I went to the Musée des Arts Décoratifs (a
museum of decorative arts and design in Paris)
and leafed through every one of Elsa Schiaparelli's
838 sketches from 1939. I found no trace of this
dress. On the advice of the museum's conservator,
I contacted Hubert de Givenchy, a former artistic
director at the House of Schiaparelli and a mine
of information on French fashion. He had never
heard mention of such a design. Dilys Blum de-
voted a major exhibition to Schiap at the Philadel-
phia Museum of Art and gave me her explanation

for the absence of this design: "During these years Schiaparelli's silhouette was slim so a fuller skirted dress might have been called 'Robe Madame Rivera.' Schiaparelli, unlike many other couturiers, did not name her dresses (they were represented by a number). However, the press was provided with a narrative that linked the disparate styles into a coherent story."

Outside the cabaret Chez Agnés Capri at 5 rue Molière quite a crowd has gathered, which is normal for a weekday evening. The waiting customers seem to know each other, and stand smoking and chatting happily in small groups. My father and Frida Kahlo arrive arm in arm, having walked across the Palais Royal gardens. Agnès Capri first attracted attention at Le Bœuf sur le Toit the previous year and is a member of the Association of Revolutionary Artists and Writers, which includes the likes of Louis Aragon, Max Ernst, André Gide, and Jacques Prévert, who writes songs that Agnès Capri performs. Everyone elbows through the door to the Petit Théâtre in the hopes of securing the best seats. Frida does not care much for the crush and cries out as she pushes people away, trying to keep some space around her.

It is a small, cramped cabaret with padded seats. The tiny stage with its purple curtain is like the set of a puppet theater. A succession of performances mixes acting with singing, and includes a set by Germaine Montero, well known for the characteristic clarity of her pronunciation and the way she freights her words with emotion. The audience supports and encourages each act with applause. Frida falls under the spell of the place. At the end of the evening Agnès Capri sings a number of emotional songs in her high-pitched voice, and Frida is very moved. When she turns to my father with tears in her eyes it makes them both laugh.

They set off into the night and decide to drop in at the Renou et Colle gallery, where Frida's paintings have now arrived. Alone on the premises at such a late hour, they unpack the paintings one by one from their wooden crates. Others are already lined up against the wall. They do not turn on the lights, but examine each piece by flashlight. In the surrounding darkness, the paintings appear in this beam of light like radiant windows, almost icons. My father feels as if his eyes are drawn in by the images. They call to him and watch him. Elements from the paintings seem to break away and come toward him: the child in the mask, the Frida with no hands, Dorothy Hale falling, the

figures in the bathtub. He has already been daz-
zled like this by certain exhibits at the Museum of
Ethnography. Although not an artist himself, he
loves and understands art, but this is not always
without consequence.

As they crouch in front of the painting *The
Heart*, he asks her why she painted a bleeding heart
in green. "But it isn't green," she replies, "my
heart's red. Any redder and you die!" He eyes her
with a questioning little smile, trying to work out
whether she is teasing him. "Do you have trou-
ble making out colors? You're not colorblind, are
you?" she asks.

A little tipsy, because there are always bot-
tles of whiskey at the gallery, she decides to look
deep into his eyes to find the cause of his color-
blindness by the light of a match, bringing it
dangerously close to him as she presses her face
against his to study him closely. The match burns
down and scorches her fingers. "It's fantastic,"
she cries, "I can see a landscape . . . and I can see
myself too, inside your eye!"

He may not have very good color perception but
she confesses that she does not have a good sense
of smell, she smells nothing, not the stench of shit
nor the fragrance of roses. They are both caught
up in the same urge to laugh because they know

that they are united in a feeling of corporeality, a shared sensory field which could be summarized as "You are my eyes, I am your nose, together we are a whole."

From the far end of the room where they have cuddled together in the shadows they watch the day dawn through the window and give a playfully idiotic commentary on passersby hurrying along the wet sidewalk: newspaper vendors, a pair of police officers shrouded in capes and laughing as they smoke, elegant young women heading off to work, and deliverymen unloading milk from a truck.

As she did with Diego Rivera, Nickolas Muray, and other lovers, when she is with my father Frida soon experiences a childlike happiness, and this manifests itself in invented gestures and little rituals that evoke the world of animals and magical thinking. For example, every time they leave or return to the house on the rue Hallé, whether together or alone, they greet their "Mayan friend," a small figure that they made out of bread dough, then painted and put inside the letter box in the garden gate. She calls my father *Red Nose*, and he calls her *Magenta*, *Joan of Arc*, and *My Little Maypole*.

And yet, whatever may unite them in these moments of elation that make Frida happy, a less cheerful overall image is emerging: Frida goes

through life with a sort of languor, a sadness, as if there were a veil over everything. My father confided in Nancy on this subject: "She was neither exuberant nor timid, in fact she was rather indifferent, definitely very affected by her own misfortune and quite neurasthenic."

MEXICO

My father studied Mexican civilizations when, between 1932 and 1936, he worked at the Museum of Ethnography, first as a volunteer and then as associate director of the Sub-Saharan Africa department. Professor Paul Rivet, a friend of his parents who ran the museum, was an Americanist who was passionate about Mexico. He had worked on the cosmology of ancient Mexicans and their representation of the world and space. Rivet's disciple Jacques Soustelle, who was the same age as my father, told him about the Lacandon people (the self-named Hach Winik, or "True People") whom he was studying. These descendants of the Maya lived in the forests of the Chiapas region.

Soustelle had brought back artifacts for the museum: necklaces, pieces of pottery, and a musical instrument made from an animal's horn.

My father was close to the photographer Pierre Verger, who worked with the museum and had traveled all over the country for a book called *Mexico*, published in 1938. He had been captivated by the nationalist cultural renaissance, and shared the view of French left-wing artists and intellectuals that Mexico was a successful revolutionary political model. Adhering to the codes of ethnographical photography, he had documented every aspect of life in the country: landscapes, faces, objects, craftsmanship, religion, pre-Columbian monuments, public holidays, markets, and clothes.

My father also met Antonin Artaud, who had broken away from the surrealist movement. He had gone to Mexico in 1936 to escape his usual routine and find a new concept of mankind. Artaud felt that Europe's rationalist culture had collapsed, and he hoped to draw new strength from the magical culture of the Mayans. He had traveled to the remote and inaccessible Sierra Tarahumara to find an ancient civilization rooted in shamanism and trance. After experimenting with peyote, he descended into an intense state of personal crisis for several months. Hallucinating and

wild-eyed, he believed he had invented a new language based on his visions. He saw the outlines of animals and human faces and bodies inscribed in the shapes of rocks and mountains.

By the late 1930s my father may well have dreamed of making his own trip to Mexico, a combination of Soustelle's ethnographical investigations, Henri Rousseau's exotic fantasy, Breton's surrealism, the adventures of Costal the Native Mexican, and Artaud's initiatory travels. When he meets Frida he is especially receptive to the fact that she is from Mexico because he already has a fairly clear idea of the country and its culture—unlike most people she meets in Paris. But he is more attracted to her personality and her culture than her exotic "ethnic" appearance. The many hours he spent over his years at the museum studying objects from all over the world meant he was desensitized to the "exotic-erotic" prejudice and its colonial backdrop, which still influenced Breton and the surrealists despite their anticolonial stance. Anyone who attempts to identify a country and its culture by associating it with a philosophical and artistic movement invariably puts forward an ethnocentric notion that submits the subject to his or her

own vision. Mexico had no need for surrealism to exist. In fact, the opposite happened: surrealism hoped to be regenerated by its contact with Mexico.

My father attended Marcel Mauss's ethnography classes while he was at the Trocadero Museum. Among his papers I came across typed-up notes from one of these classes: "The correct methodology of observation is to draw up an inventory from an esthetic point of view while being sure to include more transient and fragile objects: feathers and flowers that have distinct meaning when worn in different ways and in particular situations by the Tahitians; celebratory cakes in Annam that are true works of art; waffle irons like those in the museum of folklore in Honfleur...Every item must have a 'where, who, when' record."

To him everything was important, and he established no esthetic hierarchy of objects. In fact he considered them according to their usage value rather than their esthetic value. It was when he came into contact with Charles Ratton, the surrealists, and Picasso that he learned to see these everyday items as works of art.

As a child I remember being enthralled when my father described the atmosphere at the Museum

of Ethnography at Trocadero in the mid-1930s:
"Everyone worked in the same room, and there
was Rivière's desk, Rivet's desk, and the librar-
ian. And then there were the people in charge of
different countries as well as volunteers, some of
whom turned up more regularly than others. We
unpacked objects from the trunks sent by colonial
administrators and wrote descriptions of them on
forms that complied with an international, ten-
point format."

His friend the poet Robert Desnos came along
as a volunteer to fill in forms, but by nine in the
morning was usually already slightly under the in-
fluence of drink.

> *There was one rather entertaining day: Rivière's
> secretary was the daughter of a Russian general and
> quite cute. Desnos was more drunk than usual when
> he arrived that morning and he kissed the girl on the
> mouth with no preamble. She started screaming, so
> I tried to hold on to Desnos, who wanted to chase
> her all around the museum. The girl kept screaming,
> "Let me go! Help!" and Rivière had the hardest time
> persuading her to stay and not say anything to her
> father . . . We used to have fun dressing up in ethnic
> clothes, or we'd take blowpipes and arrows and take
> aim at targets that we'd put on the library door. I*

remember the short sharp thud the arrows made as they
drove into the wood.

The first time Robert Desnos meets Frida Kahlo, he whispers to my father, "Your friend's pretty, she could have stepped right out of a display at your Museum of Ethnography..."

She is wearing a long black skirt with white edging, teamed with an embroidered red huipil, a traditional sleeveless top usually in cotton or satin. The two men watch her talk, they watch her move. "Well, would you believe, a few years ago she decided that from then on she would only wear traditional indigenous Mexican clothes," my father says with a note of admiration, before adding, "The women in Tehuantepec never wear panties." Desnos turns to him with a smile and one of his schoolboy jokes, "Well, you'd better watch out for gusts of wind, my friend!"

Diego Rivera arranged to have belongings of his and Frida's sealed up in two bathrooms in the Casa Azul. They were opened in 2004, long after the couple had died. Among other things,

they contained the letters that my father wrote to Frida, but also, and more significantly, her wardrobe, which comprised 168 outfits.

Her clothes were mostly from the Oaxaca region, the Isthmus of Tehuantepec, and the Veracruz region. The women of Juchitan de Zaragosa in the Oaxaca Valley were known for their intelligence, beauty, strength, and courage. They were descended from the two-thousand-year-old Zapotec civilization, a matriarchal society in which women were head of the family, oversaw trading, and ran their community's economy. Frida Kahlo felt a bond with these women, and wore their traditional clothing, using it as an emphatic signal that she was of the Mexican people. She went on to turn herself into an authentic Tehuana woman, wearing huipils, some of them embroidered by hand; rebozos; and full, long skirts with or without pleating, made up of horizontal bands of fabric in bright colors and often different fabrics. The patterns on these clothes, which were embroidered or woven, included stylized geometric shapes and animal and plant designs, some of which date back to the pre-Columbian era. Frida liked making, altering, and embroidering her clothes herself.

In self-portraits Frida Kahlo shows herself as she would like to see herself, with a multiplicity of different combinations of clothes that pay homage to traditional Mexican and pre-Columbian culture. Hayden Herrera thinks that Frida chose these traditional outfits to please Diego, who loved Tehuana women and their clothes. He often visited the Tehuantepec region to draw or paint people going about their day-to-day lives. He is even said to have had romantic dalliances with local beauties. But old photographs of Frida's mother's family show that Frida's relations wore Tehuana costumes; from which we might infer that she wanted to establish her connection with this side of her family, which included Native Mexicans. This question of identity was very important to Frida and may have held more weight in her choice of clothes than her husband's preferences.

In any event, Frida Kahlo found several ways of asserting her "Mexicanness." She modified her first name, as her father had before her, so that Frieda—with its Germanic resonance—became Frida. She also changed the year of her birth, moving it from its true date in 1907 to 1910, the year that saw the beginning of the Mexican revolution. Grafting

her biography into the country's history helped to give her life some coherence.

After visiting the château at Sully-sur-Loire, which seems to hover weightlessly over mirroring water, Frida Kahlo and my father walk along the river through wisps of mist that drift from the trees along the bank, intermittently masking the progress of a group of swans.

They stop for *vin chaud* at an auberge and look at one another in silence, in one of those rare moments of truth that some passionate lovers enjoy. Something must be said and shared in this moment. Something very intimate. On which they can each lay their foundations. It may not necessarily be an event, but rather a buried emotion whose psychological impact no one else grasps.

Frida takes the initiative by saying, "When I love someone, I want to know everything about them."

He spreads his arms and nods his head as a sign of consent.

"I'm ready," he says. "Ask me whatever you like."

"Well then, tell me what had the most profound effect on you as a child."

He describes how the First World War trauma-
tized him. His father was appointed head pharma-
cist at Vierzon hospital, and they spent the whole
war there. They lived near the train station, and,
from the age of four to eight, he watched trainloads
of injured arrive every day: some on stretchers,
some walking wounded supported by soldiers. He
could hear their cries of pain early in the morning
when the trains drew into the station. As young
as six, he was requisitioned to entertain them by
singing to them. With damaged faces, with one,
two, three, or four limbs amputated, blind, ep-
ileptic, their bodies mangled by bombs, bullets,
gas, and the cold, they were laid out in their hun-
dreds in every last corner of the hospital. He asked
them all sorts of questions and still remembers the
answers the soldiers gave him as they lay on their
beds, swaddled in bandages.

"Why've you only got one leg?"

"Because I was wounded in the war."

"Why were you in the war?"

"I don't know, I followed everyone else."

He loathed that war. To dispel the tide of emo-
tion rising in him he kisses Frida and asks the
same question of her.

She then describes her memories from a similar
age, when she was nearly seven and Zapatist forces

confronted Venustiano Carranza's troops at the gates of Mexico City. Her family gave out food to Zapata's men, who had set up camp by the Churubusco River, very close to their home in the suburb of Coyoacán. Civilians in Mexico City found themselves caught up in the conflict. The entire population was gripped by a mood of terror, and food was very scarce. Frida remembers drawing a picture of two soldiers, one from each camp and both of them covered in blood. They both wore the characteristic symbols of revolutionaries: a sombrero and a cartridge belt slung across the body.

When Frida started painting she was influenced by the European old masters, but, steered by Diego Rivera, she gradually drew more inspiration from popular Mexican art, particularly ex-votos, brightly colored images painted onto tinplate and given to churches to represent a prayer of supplication or thanks. Their style is naive, expressive, and overstated, with nothing extraneous. They depict violence, blood, suffering, and hope, and feature a combination of the imaginary and the real.

All these elements can be found in Frida Kahlo's paintings along with themes inherited from the ethos of ancient Mexicans, such as the duality of life and death and the solidarity between the plant and animal kingdoms.

It is not unreasonable to wonder whether Frida Kahlo arrived in Europe with prejudices. Surely when she fulminates against France and the French in her letters she is endorsing an existing commitment: to break off links with Europe, with her father's origins, with Western clothes and the artistic influence of France. In order to flout her paternal origins and distance herself from Nazi Germany, she even claims that her father's family is Jewish. Her in-depth knowledge of Mexican culture and history, coupled with the body of work she herself is creating, legitimize her choice to be fully and primarily Mexican and to put her faith in this choice.

PRIVATE VIEWING

As he does every Thursday, my father spends part of the night at JEP printers at 7 rue Marcadet, page-setting *La Flèche* with Jean Maze, the paper's editor in chief. "I usually helped out with checking through articles. Everything needed correcting, so we'd go over there at about seven and it would go on till one in the morning. The typesetters in their gray overalls would put the lead molds for each letter down one by one, side by side and line by line, it was very time-consuming."

This particular evening he waits until the paper is printed, standing close to the rotary presses amid their deafening roar as they operate all through the night. He watches the glide of

metallic limbs, the regular rotations of steel cylinders and the succession of taut, freshly printed sheets. He likes the smell of the ink and the warm oil lubricating the machine. At three in the morning he is back out on the street, where the road and sidewalk have a thick coating of frost. There is not a taxi in sight, and he walks for a good half hour, heading down rue Cadet and then rue Montmartre. He is hungry and freezing cold. Some men are unloading flour outside a bakery. The owner asks whether he would like to come inside to warm up. The four men are soon sitting chatting over a snack and a bottle of hooch.

As dawn breaks my father is dropped off at Denfert-Rochereau and steps through the garden gate on the rue Hallé. Frida had just woken. He opens the proof copy of *La Flèche* and reads out loud:

> *"We must thank the Renou et Colle gallery for introducing us to the work of Frida Kahlo de Rivera. This great artist is exhibiting seventeen paintings. Each work is an open door onto the infinite scope and continuity of art. André Breton," blah–blah–blah . . . "All of these images ripped out of time and a state of wonderment are expressed in such pure colors and such perfect draftsmanship that they afford glimpses of what could*

be a style . . . At a time when artifice and imposture are so fashionable, Frida Kahlo de Rivera's integrity and illuminating accuracy are a respite from many a genius's brushstrokes," etc., etc. And it's written by my friend Foucaud.

She kicks off the sheets, revealing her body, then spreads her legs and bends them slowly. Still looking him provocatively in the eye, she throws her arms in the air and cries, "Viva la vida!" The sight of Frida with her legs open, forming an *M* shape, immediately reminds him of the 1932 painting *My Birth* that he and André Breton hung in the gallery the day before. He is disturbed by this transition from the artist's pictorial world to reality. The work itself is difficult to behold and surprised him with the sheer crudeness of what it portrays.

My Birth features a bed seen from above and from its foot in an otherwise empty room. On the bed a woman has her legs spread wide and is giving birth to a huge head that lies on the bed in a pool of blood and with its eyes closed. The upper half of the woman's body—her arms, shoulders, and head, which rests on a bolster—is covered with a sheet. The pared-back setting is made up of horizontal bands: a faded blue wall, darker blue skirting

board, strips of parquet flooring that match the perspective of the bed, and a beige panel with no writing on it, representing a space for an epitaph. Hanging on the wall just above the covered head, a portrait of the Virgin Mary presides over the scene.

The painting's title and the fact that the baby's eyebrows meet in the middle indicate that this is a depiction of Frida Kahlo's birth. The mother's veiled face is substituted by that of the Virgin, who watches the child being born. The Virgin is represented as a *Mater Dolorosa* with two daggers driven into her neck, suggesting a future burdened with suffering. This realist treatment of childbirth is in keeping with pre-Hispanic tradition and may be inspired by Aztec sculptures of Tlazolteotl, "goddess of vile things," shown squatting as she gives birth to Centeotl, god of maize.

This self-portrait reveals a contradiction: it announces a birth and depicts death (the shroud over the mother's head, the child's head hanging lifeless, and the pool of blood). Familiarity with biographical details allows us to understand more clearly that Frida is haunted by her miscarriages. In addition to this, given that Frida's mother was dead when she painted the piece, she covered her face with a shroud, thereby substituting herself

FRIDA KAHLO IN PARIS

for her mother on the bed in which she was born. Frida the all-powerful wants to be three things at once: the mother, the baby, and the one giving birth to her own image in paint.

My Birth marked the conscious starting point for the narrative of Frida Kahlo's pictorial autobiography, overlaying the real with the imaginary, and the past with the present. From this point on and for the rest of her life she would endlessly reinterpret her own story.

On March 9, the day of the private viewing of the *Mexico* exhibition, my father is leafing through the newspaper *Paris-Soir* as he lunches alone at Le Dôme in Montparnasse. On the front page he reads: "Night of bloodshed in Madrid. After 24 hours of fighting, Communist rebels surrendered this morning." On the same page he sees that arrangements are being made for passive defense in Paris, with gas masks being handed out in six of the city's neighborhoods. Two hundred thousand masks will be distributed in the coming months in anticipation of the imminent war with Germany. Storm clouds are building over France;

André Breton and Marcel Duchamp are talking of leaving for the United States; Benjamin Péret and Remedios Vario for Mexico. My father feels a wave of terror and considers leaving everything— his parents, his mistresses, his friends—and going to Mexico with Frida or joining her there as soon as possible.

The private viewing takes place toward the end of the afternoon and features seventeen paintings by Frida Kahlo, some ten of them painted in 1938. There are also photographs by Manuel Álvarez Bravo, fifty-seven pieces of pre-Columbian art, forty-four assorted everyday items, and twenty-one nineteenth-century Mexican paintings.

A variety of firsthand accounts gives an idea of how the event went that day. In my father's version,

> *The Renou et Colle gallery was an intimate space with four small rooms. Private viewings were held between six in the afternoon and nine or ten at night. People came by for a while. Those leaving constantly replaced by new arrivals. It was not prestigious. It wasn't a place where people drank, it wasn't a society event. The aim wasn't*

MEXIQUE

Exposition organisée par André Breton

ART PRÉCOLOMBIEN
OBJETS POPULAIRES

PEINTURES XVIII^e — XIX^e SIÈCLE &

Frida Kahlo de Rivera.

PHOTOGRAPHIES
DE
MANUEL ALVAREZ BRAVO

Du 10 au 25 Mars 1939

RENOU & COLLE
164, FAUBOURG SAINT-HONORÉ — PARIS (8^e)

Invitation to the Mexico exhibition, March 1939

to have three hundred people, but thirty good people.
And that they did. They were friends of the Pierre Colle
gallery, of the surrealists, of Ratton and of mine. It
wasn't an event, but her work was seen and liked.

In a letter to Ella and Bertram D. Wolfe, Frida expresses how happy she is by relating the fact that she received a great many compliments, a hug from Joan Miró, praise from Kandinsky, and congratulations from Picasso, Tanguy, Paalen, and "other 'big cacas' of Surrealism."[22] And there was indeed a lot of praise. Even Diego, who was not in France, relayed his version of the private view: Kandinsky was very moved by Frida's paintings and scooped her up in front of everyone and kissed her cheeks and forehead, "his face streaming with tears of pure emotion."

Kandinsky reveals his impressions in a letter to Anna and Josef Albers, who were at Black Mountain College in the United States at the time:

Currently there is an exhibition of Mexican art on
here. We were at the opening and thought of you, you
passionate Mexicans. There are fragments of Mex. art
on show there, sculptures, that are very interesting, and
we thought of the photos that you sent. Then there is a
lot of folk art and finally a large number of pictures by

*Diego di Rivera's wife—with strong surrealist overtones.
She was present herself in Mex. national costume—very
picturesque. They say she always goes everywhere dressed
that way. There were a lot of ladies present, who looked
eccentric enough—the spirit of Montparnasse—but they
could not compete with the Mex. costume.*[23]

According to Marcel Duchamp and Mary
Reynolds, "no surrealist here or anywhere else has
done anything like it."

In a catalogue, Oscar quotes from a letter that
Jacqueline Lamba sent to Diego a few weeks later:
"The way Frida suddenly appeared out of nowhere
left everyone speechless, like a colony of silk worms
watching a train hurtle past... Everyone agrees
and recognizes that her paintings are the best by
a woman to date."

Picasso, who saw the exhibition a few days after
the private viewing, would write to Diego, "Nei-
ther Derain, nor I myself nor you could paint a
face like Frida Kahlo's faces."[24]

Jacqueline describes an animated private view-
ing, but with an isolated Frida, alone in a corner.
My father forms the impression that Frida does not
in fact ascribe much importance to being in Paris
or having this exhibition. "She was not the sort
of artist who was anxious to exhibit or discuss her

paintings. She was very detached from her work."
When Frida Kahlo came to the private viewing, it
was to say: Look at who I am; I am in pain and I
want to live, and I paint my pain, I make it visible.

No one at the private view notices that Frida
Kahlo is approached by Ramón Mercader, alias
Jacques Mornard, alias Frank Jacson, a militant
Spanish Communist who has infiltrated Trotsky-
ite circles in Paris in a matter of months. Now an
agent for the NKVD, the Soviet secret police, his
mission is to assassinate Leon Trotsky, who is still
living in Mexico in Diego Rivera and Frida's house
in Coyoacán. He hopes to gain access to the house
by charming Frida. He has taken to following her
all over Paris to make overtures to her with a huge
bouquet of flowers. He seizes on the opportu-
nity of the private viewing to hand her the flowers
and insinuates that she should introduce him to
Trotsky. Frida replies cautiously that she is not the
right person to do this because she is on bad terms
with Trotsky. A disappointed Mornard offers the
bouquet to the first woman he sees as he emerges
from the gallery; she panics and runs away, aban-
doning the flowers in the gutter.

Ramón Mercader eventually seduced an Amer-
ican Trotskyite sympathizer in Paris, Sylvia Age-
loff, who had access to Trotsky because one of her

sisters was his secretary. They set off for Mexico in October 1939. When her sister "conveniently" fell ill, Sylvia replaced her and she introduced Mornard to Trotsky. On August 20, 1940, after a number of visits during which Mornard claimed to be writing an article about Trotsky, he cracked his subject's skull with an ice ax.

Frida Kahlo's biographers do not mention any newspaper articles about the exhibition other than the one in *La Flèche*, even though in an interview my father suggested looking at the periodical *Beaux-Arts*, published by Georges Wildenstein, who owned the gallery at 140 faubourg Saint-Honoré. On the strength of this, I found the unsigned article, which is critical of Frida Kahlo's paintings and ironic about André Breton:

> *The Mexico exhibition is André Breton's work. Alongside anonymous eighteenth- and nineteenth-century Mexican paintings, everyday trinkets and terracotta artifacts from before Cortes's invasion, it includes paintings by Frida Kahlo de Rivera, the wife of the famous painter Diego de Rivera. I feel there is no point in insisting the exhibition is of any interest. It gives off a whiff of death and demonic life. This latent satanism*

*appears everywhere . . . Frida Kahlo de Rivera is a
necromancer. The surrealists appear to be claiming her
as one of theirs. What they are forgetting is that she
seems most like a spiritual sister of Pierre Roy, who was
blacklisted by the group!*[25]

A more neutral article appeared in the periodical *Marianne*: "It is only right to give particular mention to the paintings of Frida Kahlo de Rivera, in which this traditional background is allied with contemporary surrealist anxieties. André Breton is quite right in identifying this as very much a woman's work, in other words by turns utterly pure and utterly pernicious: a ribbon around a bomb."[26]

In April 1939 French *Vogue* settles for mentioning "adorable eighteenth- and nineteenth-century Mexican paintings."

The day after the private viewing, my father, who is leaving Paris, writes Frida a letter:

*Frida, the train's moving. I'm sad to be leaving, I didn't
stay at the exhibition very long. It's a lovely exhibition. I
didn't think it would be so lovely. Frida's lovely, but then
everyone knows that. I hope you weren't too tired. I'm*

Letter from Michel to Frida, March 10, 1939

*very sorry I won't be with you tomorrow evening when
you go to Pierre Colle's place. Magenta—if you need
even the tiniest thing, call me on Hyères 291 (Var)*[27] *it's
not easy for me to make calls. I'm proud of you, Frida.
I'm sending you lots of kisses. Hello. Sorry. Michel.*

Underneath this he writes, "Between Laroche
and Dijon. 10. III. 1939," and there is a picture
of a little train with an electric cable, under which
are the words "*Frida . . . Hello . . . Frida . . . Hello.*"

The telephone number in Hyères suggests that
he is heading for the Villa Noailles in the south
of France with his official mistress. Would he be
happier staying in Paris? Does he feel he must join

Marie-Laure to preserve their relationship, given that Frida is due to leave soon?

During the exhibition, the French state—and not the Louvre—acquired a painting called *The Frame* that is both Kandinsky's and Maurice Renou's favorite piece in the exhibition. A work that Frida herself describes as "an idiotic photo in a frame decorated with parrots, the most horrible piece of shit I've painted."

The painting was allocated to the collection at the Jeu de Paume national museum, and is currently in the Pompidou Center's collections. A file in the national archives contains the request note sent by the Jeu de Paume's conservator, André Dézarrois, to the director of the Beaux-Arts museum: "The wife of the greatest living painter in the Americas, Diego Rivera, who is herself intriguing and talented, has just had an exhibition in Paris at the Renou et Colle gallery, under the patronage of the poet André Breton. The works exhibited are surrealist in nature, some of them charming, especially a self-portrait that, before she leaves Paris and for the sum of one thousand francs, she will hand over to the collections of the

Jeu de Paume, where Mexican art is more or less nonexistent."

On July 4, 1939, André Dézarrois's volunteer assistant at the museum, Rose Valland, listed the painting in the inventory as number 929. It was the last official entry of a work in the collection before the outbreak of war. Rose Valland would go on to help evacuate the most precious works from the museum when the Nazis arrived the following year, and would be involved in salvaging many works of art during and after the war.

The French national collection was the first in the world to acquire a painting by Frida Kahlo.

On the other hand, not a single painting in the exhibition is sold, unlike the exhibition in New York, where seven were sold and three further works commissioned. Jacqueline Lamba cites nationalism and the undervaluation of women in France.[28] Frida gives Muray a different insight into the situation a few days before the exhibition, saying she does not believe in her own commercial success: "People in general are scared to death of the war and all the exhibitions have been a failure, because the rich bitches don't want to buy anything."[29]

A week after the private viewing, when my father is still at the Villa Noailles, Frida writes to her friends the Wolfes in New York: "I want to tell you: that I have missed you very much—that I love you more and more—that I have behaved myself well—that I have not had adventures nor lovers, nor anything of the kind, that I miss Mexico more than ever—that I adore Diego more than my own life—that once in a while I also miss Nick a lot, that I am becoming a serious person."[30]

Frida therefore keeps quiet about her Paris affair, even with her closest friends, to whom she usually says everything.

Meanwhile, my father has left Paris, abandoning Frida to her own fate for about ten days. Perhaps they are both trying to get some perspective on a relationship that has no future.

When I read a letter of my father's on this subject I was moved by the strength of feeling: "The episode was very beautiful in its intensity, and even in its limitations. It was a passion in keeping with André Breton's book, *Mad Love*. It couldn't last, she was right [. . .] She certainly talked of coming back but I think she took it all very fatalistically. It was

something that was over and she was going back to her old life."

While my father is away Frida Kahlo continues to see the friends whom they have spent time with together: Marcel Duchamp and Mary Reynolds, Benjamin Péret, and Remedios Vario, who live in the same neighborhood on the rue Froidevaux alongside the Montparnasse Cemetery. She also sees Wolfgang Paalen and Alice Rahon on the rue Boulard, very close to the rue Hallé. These women painters are drawn to each other from their first meeting. After Frida's return to Mexico, Alice writes to her: "When you sing that song I remember the shape of your mouth, I remember it by heart."

Frida likes seeing Dora Maar; together they talk for hours about painting, their admiration for their "great" men, Pablo Picasso and Diego Rivera, and how difficult it is to be creative around them—and even to live sometimes. They discuss the children they have not had. Frida thinks men are kings and rule the world. What remains of these visits is a charming pencil drawing by Dora of Frida on her

bed. She is on her back with her eyes closed, offered up to the viewer in an intimate pose, her left arm trailing with abandon close to her face on the pillow, her other hand on her stomach. Her face is relaxed—perhaps she is asleep—and her head decorated with flowers. In her workshop on the rue de Savoie Dora also takes some full-length photographs of Frida, the only known photos of her time in Paris.

Frida explores Paris with Jacqueline, who introduces her to the place des Vosges, the small garden behind Notre-Dame, the covered walkways on the Grands Boulevards, the banks of the Seine, the Latin Quarter, and the Luxembourg Gardens. In the Saint-Ouen flea market Frida manages to find two old porcelain dolls lying directly on the dusty ground. One is blond with blue eyes and wearing a wedding dress. Frida adores it. The other, which she thinks less pretty, is blond with black eyes. The elastic attaching their heads to their bodies has perished, giving them a wobbly, gawky quality that she finds charming and that reminds her of her childhood. She gives one to Jacqueline and takes the other home to Mexico with her.

Frida Kahlo drawn by Dora Maar

She receives several cards from my father, and puts
them on her bedside table after she has read them,
thrilled to be the center of the universe, sur-
rounded by new friends and lovers and mistresses,
be they real or potential.

During this period my father is in Hyères with
Marie-Laure de Noailles in her splendid house

designed by the architect Robert Mallet-Stevens. The building, which has twenty-five bedrooms and as many bathrooms, looks like a steamboat deposited on the top of a hillside overlooking the small town's traditional roof tiles. It is made up of different-sized concrete cubes and includes a prow, a funnel, rails, gardens, and balconies, and a large indoor swimming pool. My father likes doing his boxing training in the sports room, reading on the upper deck with Marie-Laure when the sun is shining, organizing dinners with her for her many guests, and taking boat trips to the nearby island of Porquerolles and outings around Toulon's bars with his male friends. His spirit and inquisitive nature make him very popular with friends of Charles and Marie-Laure de Noailles. In fact, Charles will later admit to my father—his wife's lover—that the house was never as cheerful and alive as when he was there.

But at the moment his thoughts are elsewhere. He cannot stop thinking about Frida and feels weakened by the distance between them. He knows that what matters to Frida is living in the moment. How can he express his longing when he is so far from her?

———————

On March 15 he goes to the station with the chauffeur to pick up Man Ray. While he waits for the train to arrive he buys the day's papers: the front-page news is that Hitler has violated the Munich Agreement and sent his troops into Czechoslovakia. The country has submitted without a fight, and the swastika now flies over the royal palace that looks out over Prague. With a sense of premonition, he remembers the ghosts of the Great War whom he met at Vierzon hospital as a boy. Can it really happen all over again?

When he returns to Paris a few days before Frida is due to depart, he goes to rue Dragon, near Saint-Sulpice, to visit a craftsman who specializes in making church communion-wafer boxes. He commissions a jewelry box: "I wanted her to have somewhere to keep her wonderful jewelry, pieces in jade, with age-old stones, in obsidian or with emeralds, and her gold necklaces. It was a small three-tiered parchment case. Inside, it had compartments and was lined with fabric in those Mexican colors Magenta and Solferino."

On March 23 Frida Kahlo and my father go to the gallery together to oversee the packing of her paintings. The pictures are taken off their hooks

and set down on the floor, leaning against the wall. She asks him to choose a painting for her to give him. He is not expecting this offer but does not hesitate long before choosing *The Heart*.

Why does he choose this particular work? Perhaps because of the night they spent at the gallery and the memory of that moment when he saw the red heart as green. Perhaps because the heart represents both passion and the pain of parting. She picks up the painting and hands it to him, saying softly, "So you don't forget me."

He gives her three photos of himself as a younger man . . . "So you remember me."

One of the pictures is of him against a background of snow-covered mountains; he is facing the camera, on skis and leaning on his ski poles with his hips tilted because of the incline of the slope. It is a beautiful day, he is wearing a polo neck, and the sun casts his shadow over the snow. On the second, which has the same background, he is more tightly framed, looking away into the distance to one side through screwed-up eyes. The third finds him in a wine cellar wearing espadrilles on his feet and long shorts that are too big for him, and drinking straight from a bottle of chianti. He is smiling as

he takes this little break, with an expression that suggests this is a setup. Behind him more than a dozen empty chianti bottles have been rammed upside down into a metal wine rack.

She gives him a photograph too, a black-and-white image of a self-portrait with a monkey. In the bottom right-hand corner she writes: "Michel, todo mi Corazon,[31] Frida. Paris 23 marzo 1939."

The next day he escorts her and her luggage to Saint-Lazare station, where Breton and a few friends are waiting. When the time comes to say goodbye my father realizes just how attached to her he is. Their separation is painful. The loyal Jacqueline accompanies Frida by train to Le Havre and watches the *Normandie* leave, taking Frida to New York.

Just like Frida, my father is a seducer and moves in surrealists' social circles where sexuality is very free. In all likelihood he enjoyed satisfaction in that area with Frida—she is open in saying that she likes "it"—but his relationship with her went beyond this. He identified her as someone distinctive and mysterious; he was aware of her unique scope.

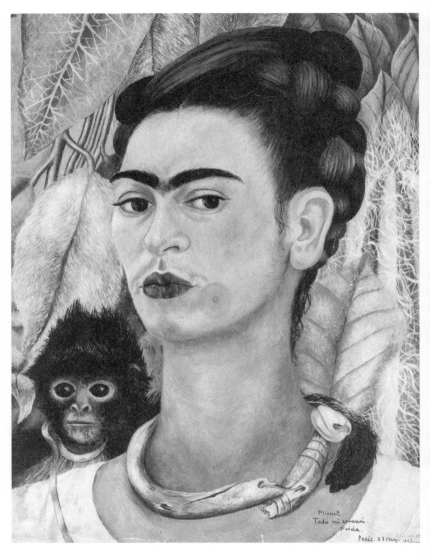

Frida Kahlo self-portrait dedicated to Michel Petitjean, 23 March 1939.

"Frida was a lady on an extraordinary scale in terms of dignity, and precision. She was naturally distinguished, it wasn't something she could have learned. She had great nobility, she was a real princess."

Having had a taste of Frida's Mexican flavor, the thought of returning to Marie-Laure de Noailles's closed but benignly decadent circles and to the threat of imminent war makes him want to escape to the world of this original, rebellious Mexican capable of producing unique paintings that reference psychoanalysis, ethnography, and a nation's history.

He gradually becomes aware of what he will lose with her gone and, in an attempt to maintain contact with her across the ocean—but also to prove that he cares for her—he comes up with a plan: "I calculated it all very carefully, when she left I sent telegrams and love letters that would be there to greet her at every stage of her journey."

Letter of March 24, 1939:

> *I find it hard to believe you've gone, I was so used to having you here. I don't have much news to tell you because this letter will be traveling with you. There is one novelty, though: I can tell you that I'm thinking of you*

*even when you're the other side of the Atlantic, and that
I love you very very much even when you're the other side
of the Atlantic. Good night, my dear little maypole, jump
into the sunshine, give your monkeys a kiss, and don't
drink too much in New York. With my love, Michel.*

Radio-telegram sent from Paris via Saint-Nazaire,
March 25, 1939, at 10:32 p.m.: "Madame Rivera.
Passenger Normandie FFK. *Hello Frida. Michel.*"

She replies by telegram the same day: *"Thinking of you so
much Michel."*

Letter of March 29, 1939:

*Frida, Frida. Paris is very empty and short on petti-
coats and flowers in people's hair. I love your painting
more and more. It's next to me as I write. It really is a
wonderful gift. I haven't done a thing since you left, I've
kept my promises, I've been a good boy, a very good boy.
Jacqueline called to tell me about your journey and to
let me know you didn't have the cases with the paintings,
those idiots at Tailleur sent them as hold baggage despite
our explanations. I'm handling the transfer of refugees to*

Mexico. Bergery has put in a request and we're waiting for a reply from the President of the Council. I'm still in touch with Gorkin and Leduc. Manuelo comes to see me every day and I'm hoping I can help him get the money he needs to leave. Saw Mary and Marcel Duchamp yesterday, very kind and very emotional talking about you, your photo presides over the downstairs room, in between the irons, it feels like the place of honor. I miss you a lot, I've gotten so used to seeing you and there are so many things in Paris I wish I'd seen with you. But I'm sure you'll come back and you'll soon forget all your Parisian problems, so then all you'll remember is a boy with a red nose who loves you very very much, that's true. Still nothing from Diego, I think the French government is going to make an official request to the Mexican government. I hope the jewelry box is behaving well. I'll send you a second key in Mexico.

I love you and send you kisses, don't forget me too quickly. Be good and be well. I'm so worried you'll have more trouble like in Paris and that you'll suffer like a poor little leaf all over again. With my love, Michel.

Letter of March 31, 1939:

Hello Frida. It feels like a year since you left and I'm sad I haven't heard from you.

*It's the first day of spring today, the sun's shining
and Paris is glorious. It's just gloomy because you're not
here to see it. I wrote to you twice at the Barbizon Plaza,
I hope you found the letters, I'm very worried about
letters getting lost, it's a physically unpleasant feeling.*

*No news about the Spanish refugees, it always takes
a very long time. Everyone here is talking about the war
and people carve up Europe as they knock back their
predinner drinks, which is very French.*

*I wish I could see you and at least have some news of
you. I'm jealous of America and the Americans. I think
I'm falling more and more in love with you.*

*"And the consequence is" I'm sending you lots of
kisses. With my love, Michel.*

April 1, 1939, marked the Spanish Civil War's end
and General Franco's accession to power. The
dictatorship that he instituted and sustained until
his death relied on the army, the church, and the
country's only political party. Collaborations,
trade unions, other parties, and strikes were
banned. France and Great Britain recognized the
regime.

———

Letter of April 7, 1939:

> *The atmosphere here is terrible and everything reeks of*
> *war, even my optimism is starting to crumble. Events in*
> *Albania[32] are the worst sort of cowardice. Mussolini is*
> *like a man who lets his wife yell at him and then takes his*
> *revenge by kicking little dogs he sees in the street. I don't*
> *know whether we can avoid going to war. It all escalated*
> *very quickly after I left you, or rather you left me. I really*
> *thought I would see you again someday. Well, we shall*
> *see . . . I send you lots and lots of kisses, that's how much*
> *I love you. With my love, Michel.*

Remembering the letters he sent that went un-
answered, he said, "It was a great passion but how
can you keep something like that going with little
notes, they don't mean anything."

AFTER THE WAR

In view of what Frida Kahlo's existence went on to be, her New York–Paris trip seems to have been one of the best episodes of her life. It was certainly a transitional period. She was independent for the first time and traveling alone, without Diego. She sold paintings in New York and was no longer financially dependent on her husband. These international exhibitions earned her recognition from the general public, known artists, and art critics. She was no longer Mrs. Rivera but had become Frida Kahlo. Long after her time in France and partly contradicting the things she had said against the country and the surrealists, she

remarked, "I did not paint anything there. I just had a high time and was idle."[33]

When Frida left Paris she was heading toward painful events. Once she reached Mexico, Nickolas Muray announced by letter that he was about to be married, abruptly bringing an end to their relationship. At the same time Diego was taking the necessary steps for a divorce. Frida so wanted to be first, but she always came second, even in her brief affair with my father. A little while later Leon Trotsky, whom she still admired in spite of everything, was assassinated very close to her home. Her world had turned upside down, provoking suicide attempts, dangerous alcoholism, constant pain, and chronic fatigue syndrome. In the ensuing years her health deteriorated, and she consulted a succession of doctors in Mexico and the United States for a variety of medical problems, most of them incurable. She underwent extensive surgery on her spine and had to wear metal and plaster body braces for lengthy periods. Suffering and depression were now integral to her daily life. Living became her life's central goal, painting her main aim.

There is a trace of her time in Paris in the 1940 painting *Self-Portrait Dedicated to Dr Eloesser,* in which Frida wears the hand-shaped earrings that Picasso gave her.

In September 1939 my father was mobilized as a noncommissioned officer in the "phony war," and in 1940 he fought in the Battle of France, during which he was injured. A few months later, back in Paris, he set up an official newspaper for French prisoners of war in Germany and secretly made false identity papers for escaping prisoners. He was denounced to the Gestapo, tried, and sent to forced labor camps in Germany for two and a half years. According to his friends, after this ordeal he was no longer the funny, spirited, sympathetic, and daring man they had known before the war; he had become more reserved and had periods of depression.

Frida Kahlo died in 1954, when I was three. *The Heart* hung on the living room wall in our home and

cohabited peaceably with a Dogon mask, a small wire sculpture of a cow by Calder, an early land-scape by Dalí, and a sketch by Max Ernst. Without realizing it, I grew up surrounded by works that were all interconnected and traced out the frame-work of my father's life before the war.

As a teenager I experienced a phase of great loneliness. It was not physical loneliness, because I was surrounded by my seven siblings and many friends; no, the loneliness was inside me. I ques-tioned things obsessively, as all teenagers do: Who was I? Where was I from? Everything seemed to be for the best: I was born in Salvador Dalí's apart-ment on rue de l'Université (very likely in his bed), and this struck me as a good omen for the rest of my life, but this biographical curiosity could not dis-guise an absence, the absence of a father figure. I did not really know who my father was, which made it impossible to see him as a role model, someone with whom I wanted to or could identify.

During this phase of mine, I was subcon-sciously helped out of my inner isolation by Frida Kahlo's painting *The Heart*, which I saw every day at home. A bleeding heart: pain. A woman with no hands: loss of self. A self-portrait: an explora-tion of identity. It all spoke to me. I sensed that the painting expressed profound and pressing issues

that were intimately connected with me. For several years I drew and painted my own anxieties as Frida Kahlo had. I put together colorful, realist, symbolic images revealing physical and psychological suffering, and questioning sexuality: desolate landscapes with no human presence, tortured vegetation, solitary figures and faces with the skin torn from them, and I altered the function and scale of the objects and people I included.

Frida's painting had opened the way for me: if I chose to, I was free to express in shapes, colors, and metaphors the things I could not formulate with words.

From about 1979, when I was twenty-eight, art historians started contacting my father about Frida Kahlo. It was then that I truly understood how important her work was. Two Americans, Nancy Deffebach and Hayden Herrera, were researching books about her and wanted information about *The Heart*, a painting no one had seen because it had been in my father's possession since 1939. They also wanted to know the circumstances under which Frida had given him the painting.

When Hayden Herrera's book *Frida* was published in 1983, requests to borrow and reproduce the painting increased; now that it had finally been discovered by a wider public, it was incorporated in the artist's body of work (which comprises some 150 pieces).

I was about to finish this book when I received a letter from Salomon Grimberg in which he told me a wonderful story. He came to see my father in 1987 to ask to borrow the painting for an exhibition in Dallas and was astonished when my father replied that he was happy to make the loan, but *in a personal capacity*. He did not want to hear mention of some museum he did not know. Although the two men were meeting for only the first time, my father felt comfortable entrusting this unique piece to Grimberg.

When the time came for Salomon Grimberg to make the return trip from Dallas to Paris to collect the painting, the flight was delayed by fog and landed in Paris at two o'clock in the morning. My father was there waiting for him, wide awake, ready to hand over *The Heart* in person.

I feel that this story says all there is to say about the man he was, sufficiently generous, sporting,

and carefree to trust a stranger on the strength of his looks alone, and lend him Frida Kahlo's painting even though he was very attached to it.

The nonconformist, bisexual, engaged artist Frida Kahlo was rediscovered by feminists in the United States and Europe in the 1980s. Her life story and her work were zealously appropriated by all sorts of people for all sorts of different reasons: her impossible relationship with Diego, her suffering because of illness, her sexual freedom, and the power of her coded paintings.

Frida Kahlo's paintings, archives, and homes have become the property of the Mexican government through the Bank of Mexico, which rigidly controls access to them and their dissemination. The average price of her paintings went from fifty thousand dollars in the 1970s to a million dollars twenty years later. My father was contacted by many people—including the singer Madonna—who wanted to buy *The Heart*.

The painting was sold at auction shortly after my father's death and I have never managed to discover who bought it or where in the world it now is.

ACKNOWLEDGMENTS

The author would like to give a special mention to his daughter Camille, and his brothers and sisters.

He would like to thank
Jaime Moreno Villarreal and Nancy Deffebach,

As well as
Aube Breton, Michèle Chomette, Ethel Hammer, Salomon Grimberg,
Martine Monteau, Dominique Rabourdin, Ruth Thorne-Thomsen,
Judith Thurman, Hilda Trujillo, Rachel Viné, Victoria Combalia, Lucie Lesvenan,
and Éditions Christian Bourgois.

NOTES

1. Julien Gracq, *Reading Writing*, translated by Jeanine Herman (New York: Turtle Point Press, 2006), pp. 297–98.

2. Frida Kahlo to Nickolas Muray, February 16, 1939, https://www.aaa.si.edu/collections/items/detail/frida-kahlo-paris-france-letter-to-nickolas-muray-new-york-ny-491.

3. "Old man"; used as a term of affection.

4. Variously translated as "objective chance encounters" and "objective coincidence."

5. André Breton, quoted by Christine Frérot, "Théorie au pays des esprits," *Mélusine,* no. 19 (L'Âge d'Homme, 1999).

6. *Encyclopedia of Contemporary Latin American and Caribbean Cultures*, edited by Daniel Balderston, Mike Gonzalez, and Ana M. López (New York: Routledge, 2000), p. 1432.

7. Claude Mauriac, *Le temps immobile* (Paris: Grasset, 1976).

8. Frida Kahlo to Nickolas Muray, February 16, 1939.

9. Gabriel Ferry, *Costal l'Indien, scenes de la guerre d'Indépendance du Mexique* (Paris: Hachette et Cie, 1852).

10. Frida Kahlo to Nickolas Muray, February 16, 1939.

11. Frida Kahlo to Nickolas Muray, February 27, 1939, https://www.aaa.si.edu/collections/items/detail/frida-kahlo-paris-france-letter-to-nickolas-muray-new-york-ny-761.

12. Leon Trotsky, "Art and Politics in Our Epoch," *Partisan Review*, June 18, 1938, https://www.marxists.org/archive/trotsky/1938/06/artpol.htm.

13. Gannit Ankori, *Frida Kahlo*, Critical Lives (London: Reaktion Books, 2013), p. 115.

14. Hayden Herrera, *Frida: The Biography of Frida Kahlo* (London: Bloomsbury, 2003), p. 75.

15. Salomon Grimberg, "Frida Kahlo's *Memory*: The Piercing of the Heart by the Arrow of Divine Love," Woman's Art Journal 11, no. 2 (1990–91), pp. 3–7.

16. *The Life of St. Teresa of Jesus, of the Order of Our Lady of Carmel. Written by Herself*, translated from the Spanish by David Lewis, chapter 29, section 17 (1904).

17. Herrera, *Frida*, p. 251.

18. John Berger, "The Fayum Portraits" (1988), in *The Shape of a Pocket* (London: Bloomsbury, 2002), pp. 53–60.

19. Walt Whitman, "Song of Myself," https://whitmanarchive.org/published/LG/1891/poems/27.

20. Herrera, *Frida*, p. 109.

21. "Fashion Notes," *Time*, May 3, 1948, pp. 33–34.

22. Herrera, *Frida*, p. 252.

23. Jessica Boissel and Nicholas Fox Weber, eds., *Josef Albers and Wassily Kandinsky: Friends in Exile, a Decade of Correspondence, 1929–1940* (Manchester, UK: Hudson Hills Press, 2010), p. 141.

24. Gérard de Cortanze, *Frida Kahlo, la beauté terrible* (Paris: Albin Michel, 2011), p. 119. Also Raquel Tibol, *Frida Kahlo: Una vida abierta* (Mexico City: Universidad Nacional Autónoma, 2002), p. 103.

25. *Beaux-Arts*, no. 325, March 21, 1939.

26. *Marianne*, March 22, 1939.

27. A department of France in southern Provence.

28. Herrera, *Frida*, p. 250.

29. Frida Kahlo to Nickolas Muray, February 27, 1939.

30. March 17, 1939. See Herrera, *Frida*, p. 252.

31. Michel, all my heart.

32. Italy invaded Albania on April 7.

33. Salomon Grimberg, *Frida Kahlo: Song of Herself* (London: Merrell, 2008), p. 82.

IMAGE CREDITS

MARC PETITJEAN is a writer, filmmaker, and photographer. He has directed several documentaries, including *From Hiroshima to Fukushima*, about Dr. Shuntaro Hida, a survivor of the atomic bombing of Hiroshima; *Tresor Vivant*, about a Japanese kimono painter; and *Zones grises*, on his own search for information about the life of his father, Michel Petitjean, after his death.

ADRIANA HUNTER studied French and Drama at the University of London. She has translated more than eighty books, including Veronique Olmi's *Bakhita* and Herve Le Tellier's *Eléctrico W*, winner of the French-American Foundation's 2013 Translation Prize in Fiction. She lives in Kent, England.